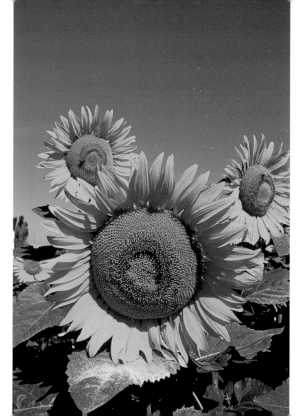

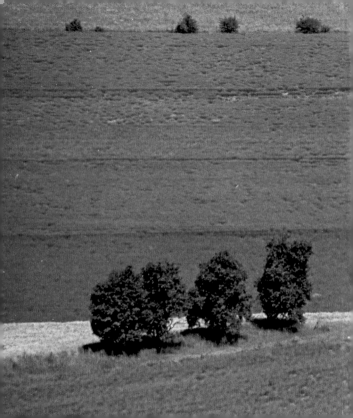

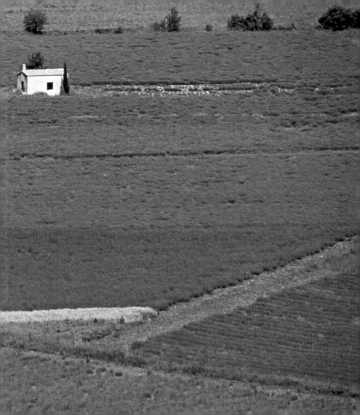

ABBEVILLE PRESS PUBLISHERS

New York ✑ London ✑ Paris

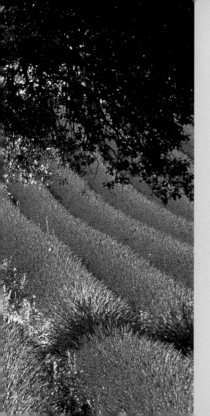

IN SEARCH

OF LIGHT

AND

PARADISE

In Search of
Light and Paradise

I t's six o'clock in the evening and the village is still flooded
with sunlight. You buy some Provence rosé at a local shop
that also sells children's swimming pools, artificial flowers, real
peaches, chaises longues, screwdrivers, vegetables, and even a single
dress—just in case. You stroke the cat stretched out on a blue chair
near a blue window, or perhaps on the hot stone rim of the fountain,
and wind your way back up the hill. On the opposite slope a golden
haze envelops the vineyards, obscuring them from view.

The house is at the end of a dusty road, lost in the song of the
cicadas—who don't sing at all, of course, not even in "ancient Greek"
as van Gogh thought: they click. Deep in the Midi one can no longer
tell whether it's their clamor that dazzles or the light. Now they go to
it with a will, as if trying to slow the fall of night. They're making up
for lost time, they're holding fast to their short lives. Three years of

larval, subterranean existence for a few weeks of light. All we know of the cicada, this invisible uproar, is the noise of its nuptials. These begin in late June, and toward the end of August the exhausted insect lays its eggs, drops to the foot of its tree, and dies, devoured by neighboring ants. La Fontaine was prone to euphemism: "mating done, utterly stunned"; in reality, the poor thing was totally digested.

The house at the end of the road is drowning in oleanders, geraniums, and mimosas. One could spend hours at a time seated on the warm stone of its little wall, watching the summer vibrate above the vineyards. Beyond the shed with its three cypresses, there's nothing but transparent sky and ocher earth, torpid after the hot day. Everything in this world is so beautiful, everything is so pure, including the mountains behind which the sun is about to disappear, that you envision returning here one day to remain for a thousand years.

"Naturally you love Provence. But which Provence?"—Colette

There's more here than the sweetness of things and the exuberance of flowers. There's also rocky, solitary terrain eroded by winter, ice, and hurricanes. And there's Le Ventoux, very well named (*vent*, "wind"), on whose slopes a small poppy from Greenland flourishes. At the beginning of the century, after publication of the first Tourist

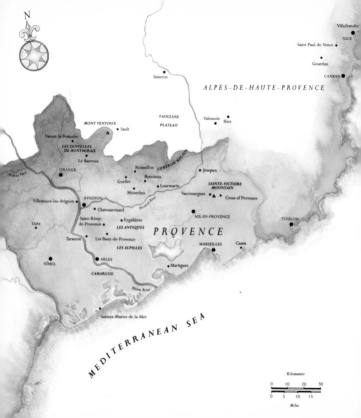

Guide to Mount Ventoux, women dressed in bear skins could be seen climbing it to applaud the magic of the rising sun. But most of the time it's the domain of sheep that turn over its rocks in search of a bit of soft grass.

There are fountains and Roman ghosts, fields of lavender and oceans of sunflowers. Marvelous villages invaded by Martians in shorts, barbecues in the open sun, art galleries that double as crêperies. There are cities and crowds drawn by festivals. Petrarch, who loved Provence, detested Avignon, speaking of it from the depths of his fourteenth century in terms not so different from those of a festival-goer today who finds the hubbub of its crowds eminently resistible: "It's a sewer in which all the filth of the universe ends up. There God is scorned. There money is worshiped, human and divine laws are trodden underfoot. Everything about it reeks of deceit—the air, the earth, the houses, and above all the bedrooms."

And then there's the sea. "I am a child of the mountains, I hate the sea, it terrifies me," wrote Jean Giono, who was comfortable in wild landscapes. Marcel Pagnol, a filmmaker, who was born in Aubagne and rarely traveled farther north, was unfamiliar with northern Provence. What common thread ties together its dry plateaus, the Mediterranean, and the lights of its old port; the fields of sunflowers and the

lugubrious silhouette of the château of the Marquis de Sade; Colette, who professed to crush garlic "as if committing murder," and Vincent van Gogh, who cut off his ear to soothe his pain? There are a thousand and one Provences, and their sole shared trait is excess—of colors, climates, passion—and ravishment.

To be sure, a popular dictum has it that olive trees refuse to grow above Nyons. As the olive is an indisputable "proof" of Provence, one might say that its northern limit is Nyons. To the west, though kept in check by the Rhône, it nonetheless overflows into the Camargue—that other planet that the ancients took to be the antechamber to the Land of Shades—and it was at Saintes-Maries-de-la-Mer that van Gogh, seeing the Mediterranean for the first time, found it to be "the color of mackerel." To the east, Provence extends as far as Antibes, where Nicolas de Staël went to paint and die above the ramparts. But outside of these subjective geographic markers, each of us finds the Provence of his or her dreams—rooted in the striking realities of the real one.

"In this parceled-out land, purchased by the square meter, rented out by the week, open day and night, I'm most attached to what remains strangely harsh and imperturbable."—Colette

Deeply enamored of the veiled sunlight of the Channel, Colette was

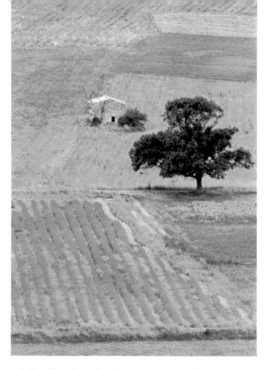

fields of lavender and sunflowers ❧ MONT VENTOUX REGION

fifty-three when she fell in love with the south of France and bought a house in Saint-Tropez. "I found it by the side of a road that scares off automobiles," she wrote, apparently annoyed—already in 1926—by the ubiquity of tourists. "They drive, stop to drink, sweat, then drive on and drink again. They say: 'This region would be delightful if only it weren't so hot and the food were bearable.' Everywhere they clamor for their steak and potatoes, cooked just right, their eggs and bacon, their fresh spinach and favorite coffee."

At the Treille Muscate, as this house was known, where Paul Géraldy, Dunoyer de Segonzac, and Francis Carco came to lunch on the terrace beneath the shade of a wisteria, there were orgies of garlic mayonnaise, bouillabaisse, allspice, and olive oil. Life was lived, at least for a time, with the pleasure and intensity of first love. Colette described her existence at the Treille Muscate in 1926 and, rereading the text four years later, was herself amazed: "It's very touching, this lyricism of first encounters. . . . I write of mussing the vines. Mussing the vines! What can have been running through my head? Vines, when they're green, one ties them down, and when they're dried out, one cuts them—very short, if you please." She also dreamed of having a Provençal garden that was wild, unkempt. But in fact her gardener—"a charming dark man with frizzy body hair"—favored impeccable rec-

tangles and scrupulous geometries. She rebelled, for the result looked like a "barbecue grill." And the frizzy man answered her very patiently, in a thick Provençal accent tinged with regret: "Ah! If only I could do otherwise. If only it were easy to shift things around. Already last year you had me plant reeds facing the other way, and by August nothing was left of them." He explained to her that the sun dictated that particular placement. Perfection is not of this world, however, and in the end she got her garden of "raging flowers" thanks to God, the mistral, deep frosts, and hardy survivors. But she ended up asking herself what there was about it that was particularly Provençal in character. Nothing: no ornamental vegetables, none of the typical disorder. No rare flowers, "but a privileged sky extends above it," and this was the secret. "Now I know what a Provençal garden is: it's a garden whose superiority over all others derives from one thing only—from its flowering in Provence."

"In short, I think life here is a happier thing than in countless other spots on the earth."—Vincent van Gogh

Van Gogh arrived in Arles in February 1888. He came "to see another light," a clearer sky. He wrote his brother Theo letters full of ardor and enthusiasm. He came in search of Japan and found it in "the

limpidity of the air and the gay color effects." On other occasions he preferred to see it as Holland, or even as "the Africa close to oneself." He rented a little yellow house with green shutters in the Place Lamartine and sent Theo a sketch of it "under a sulphur sun, under a pure cobalt sky." For the sake of clarity he wrote "blue" in the middle of his drawing's black and white sky.

In 1870 Cézanne, fleeing the draft at the time of the Franco-Prussian War, sought refuge in L'Estaque, among the bare rocks and wild terrain in which his friend Emile Zola had spent his youth. Zola always cherished his memories of this landscape: "The red earth bleeds, the pines sparkle like emeralds, the brilliant white of freshly washed laundry stands out against the rocks." It was here that Cézanne, discovering the "frightening" sun on the red roofs, the hills, and the sea, wrote to Pissarro: "It seems to me that objects stand out in silhouette not only in black and white, but in blue, red, brown, and violet. I could be mistaken, but this strikes me as the opposite of conventional modeling." An important discovery, not only for Cézanne—who would attempt to render the effect created by perpetual movement of this light over objects solely by means of color rhythms—but for all the painters who followed in the footsteps of the "master from Aix."

Born in Aix-en-Provence, where he befriended Zola in school,

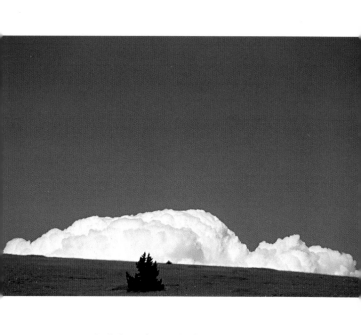

clouds during the mistral � MONT VENTOUX

Cézanne abandoned his law studies to go to Paris; but, proud of his Provençal origins, he obstinately retained his southern accent and always returned to "this old native ground that's so vibrant, so rugged," to paint precariously perched towns, the twisted trunks of olive trees, and of course Mont Sainte-Victoire, whose secret geometry he was determined to transfigure. What he sought—and his quest would be rife with implications for the history of painting—was a "harmony parallel to that of nature," one that, in its focus on individual sensation, was more profoundly faithful to nature than any kind of realism.

In 1882 Renoir, who had known Cézanne in Paris and maintained almost fraternal relations with him, visited him in L'Estaque. Some years later they painted together in the environs of Aix. Then Renoir settled definitively in Cagnes-sur-Mer, in a modest house at the foot of the hill that on one side overlooked the old town—a labyrinth of courtyards and narrow streets pressed against the steep terrain—and on the other side, between palm trees and oleanders, the sea. (La Marina did not yet spoil the view of the horizon.) "In this marvelous landscape, it's as though misfortune can't reach you," he said. Before long he would have to fix his brush to his fingers, which were deformed by illness, and have himself carried where he wanted to go, but he continued to paint,

with a formidable joie de vivre, the flowers and olive trees in his garden, blooming female flesh, and the rosy cheeks of children.

After Cézanne, an entire swarm of early twentieth-century artists came to seek out the charged Provençal atmosphere and reinvigorate painting. Matisse, Dufy, Braque, Derain, Chagall, Picasso, and later Nicolas de Staël—all came here to work, together or in solitude, to remake the world, to confront their visions of it, even if there was sometimes disagreement over the results.

They're all gone now—Colette, the painters, the marquis, and others—and Provence is no longer what it was. Or so we're told. People say it's been invaded, disfigured, overcrowded, loved only too well. All this is doubtless true. But after all, no one compels us to visit Les Baux on a Sunday in August, in shorts, with a sack of provisions over our shoulder. "Invasions" can be effected with a certain discretion, and Provence the beautiful still exists—as seen in this book's pictures. It's all the blues of the sky and the ocher of the earth, sun and shadow dancing over a pink wall, a cypress that will never leave the tiny shack over which it keeps watch. It's this house in the vineyard where you, too, have come in search of light and paradise.

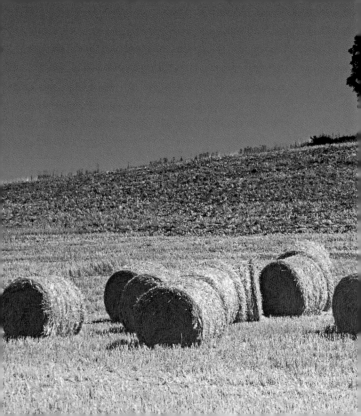

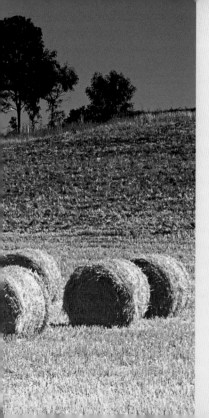

FIELDS

FIELDS

I n general, geometry is an exact science. Here it indulges in dreams, heightened by chance and the providential juxtaposition of colors. The fourth side of the square isn't straight, it follows the road winding toward the house. The lines of brown furrows—brown laced with violet—mold themselves to the gentle incline of the hill. A solitary tree rises from the tawny ground with a stubborn air, as if determined to live out its existence just there, in the middle of nowhere. And when a field is allowed to go to seed, it's invaded by impressionist flowers that tremble in the sun: corn poppies from the Alpilles or Vauvenargues. But there are also cultivated flowers, which are picked on the hottest days of summer to make perfume, while a peasant, stationed between the shadow and the light, brings to mind a similar figure described by Giono: "He is standing in front of his fields. He wears full pants of brown corduroy and seems dressed in a fragment of his labors."

PAGES 22-23: *wheat fields* NEAR VAISON-LA-ROMAINE

OPPOSITE: *farm* LE BARROUX

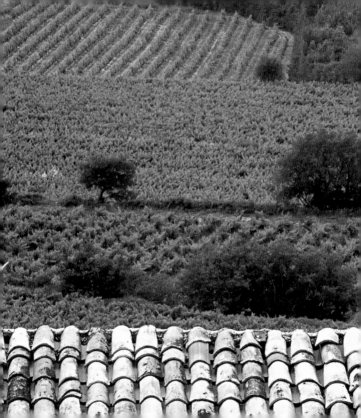

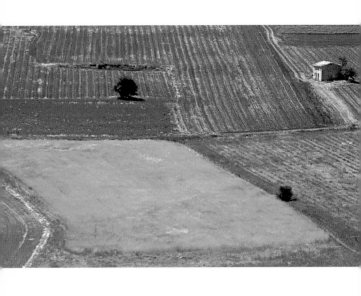

farm ✿ MONT VENTOUX REGION

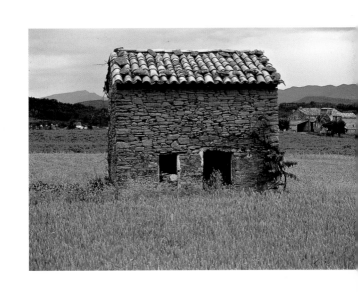

farm ❧ DENTELLES DE MONTMIRAIL

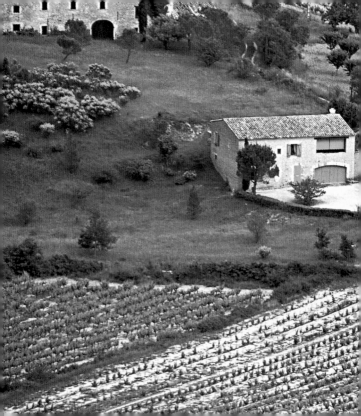

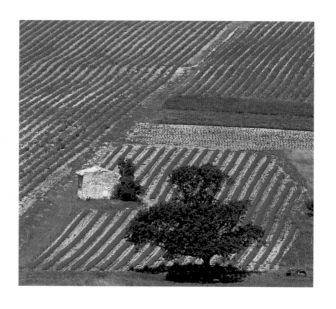

ABOVE: *farm* ✍ MONT VENTOUX REGION

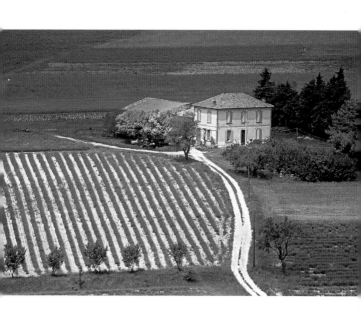

PAGES 32-33: *vineyards and fields* ✿ LES BAUX-DE-PROVENCE

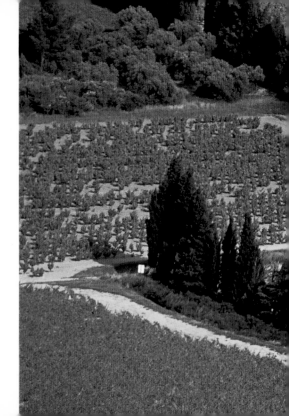

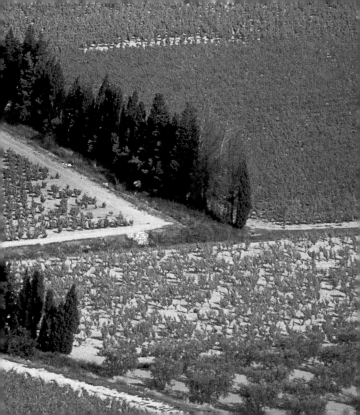

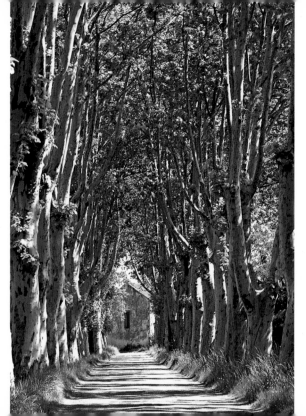

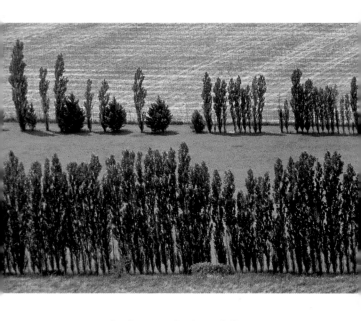

ABOVE: *poplars forming windbreaks in a field* ᏗᏗ SAULT

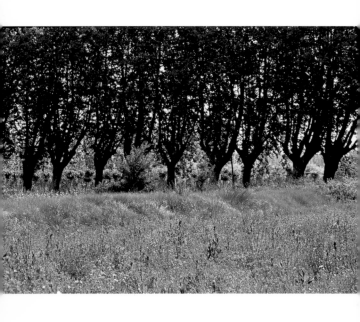

poppies 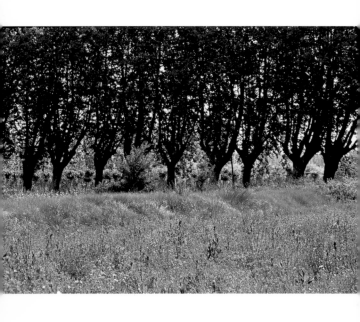 LES ALPILLES

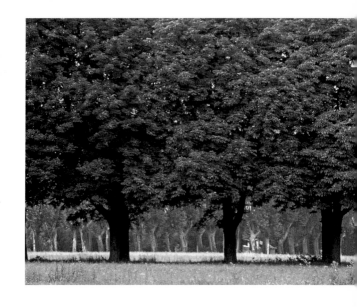

PAGES 38-39: *olive grove and poppies* ✍ LES ALPILLES

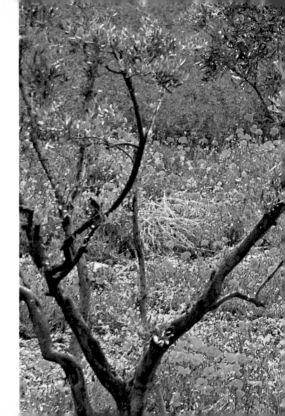

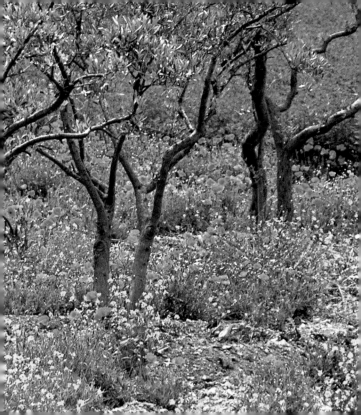

ABOVE: *poppies* ❧ LES ALPILLES

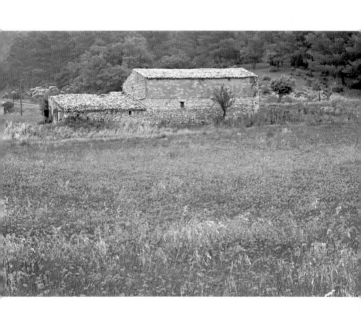

poppies ✍ Vauvenargues

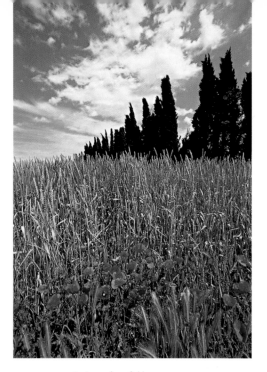

poppies in a wheat field ❧ LES ALPILLES

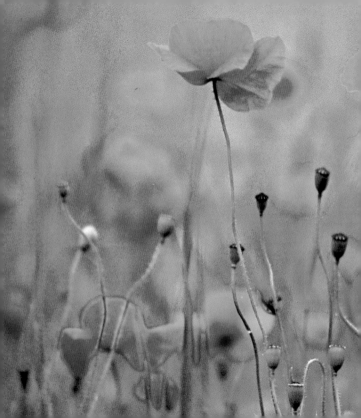

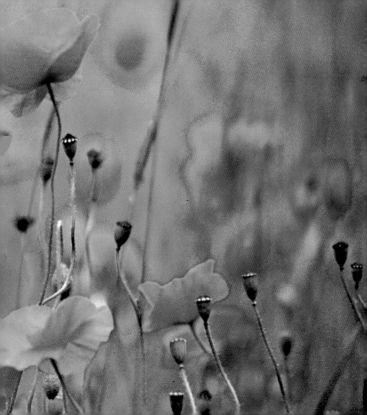

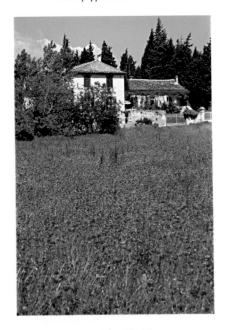

OPPOSITE: *poppies* MÉNERBES

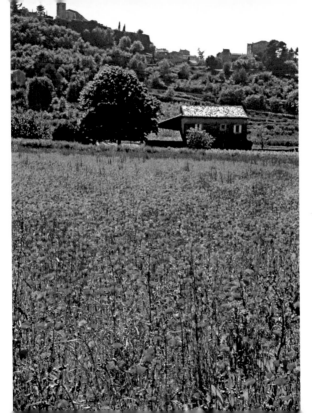

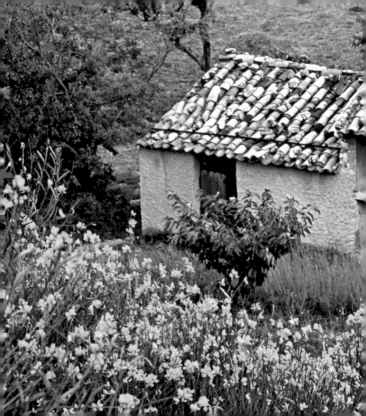

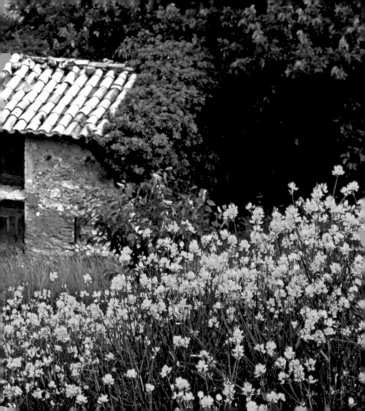

PAGES 50-51: *broom* ✺ La Roque Alric, Beaumes-de-Venise

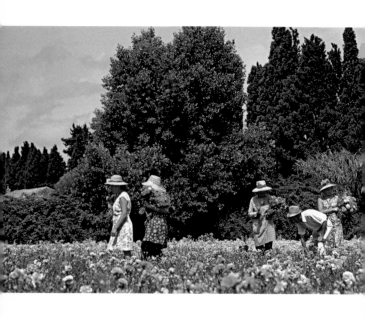

ABOVE: *gathering flowers* ✺ NEAR Saint-Rémy-de-Provence

52

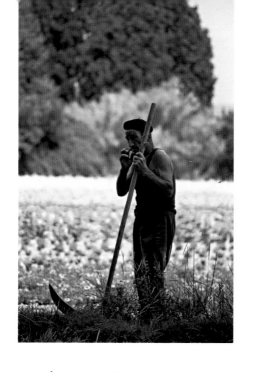

farmer ✍ NEAR SAINT-RÉMY-DE-PROVENCE

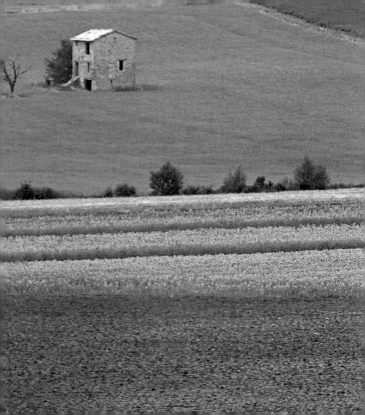

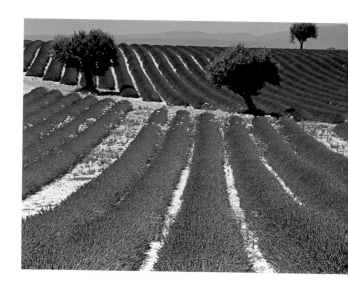

LAVENDER

&

SUNFLOWERS

LAVENDER & SUNFLOWERS

Lavender has a delightful smell as well as many other fine qualities. There is male or spike lavender, whose oil was used as a dilutant by Renaissance painters. Some maintain it was this that imparted a particular brilliance to Rubens's colors. There's also a female or medicinal lavender, widely used in inhalants for the treatment of bronchitis and in skin liniments. It's even claimed that rubbing a bit of this lavender between one's fingers will provide relief for a dog bitten by a snake, but this seems doubtful. And then from June to September these violet clouds, these rotund masses become the province of working bees.

Oil is also fabricated from sunflowers, which obsessed van Gogh, who eventually managed to instill in Gauguin something of his fascination with them, while Colette wrote of them that their round centers seemed like "black honey cakes"—a rapturous, radiant flower multiplying the sun a thousandfold, following its path from dawn to dusk.

PAGES 54-55: *lavender and sunflowers* MONT VENTOUX REGION

OPPOSITE: *sunflowers* SAINT-RÉMY-DE-PROVENCE

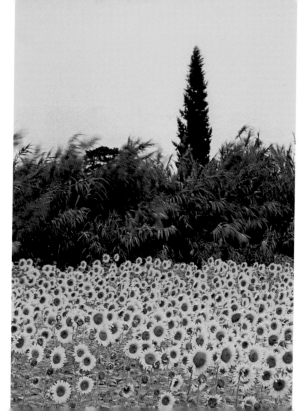

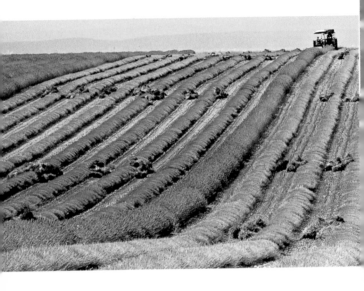

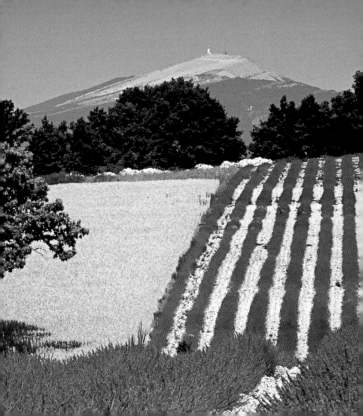

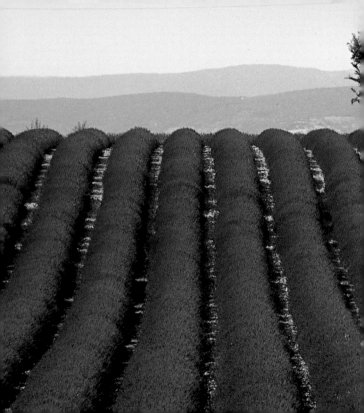

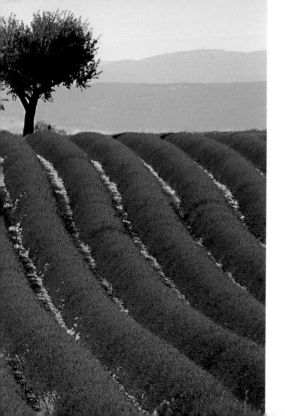

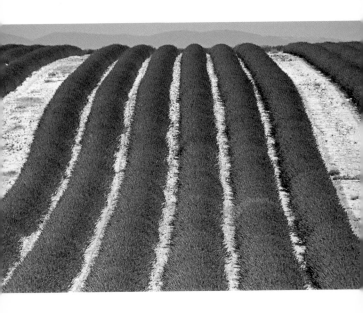

ABOVE: *lavender* VALENSOLE

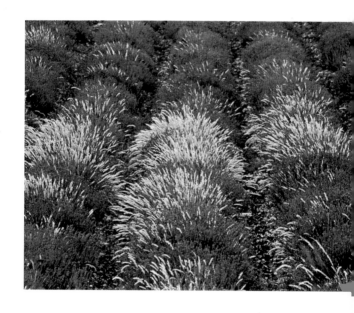

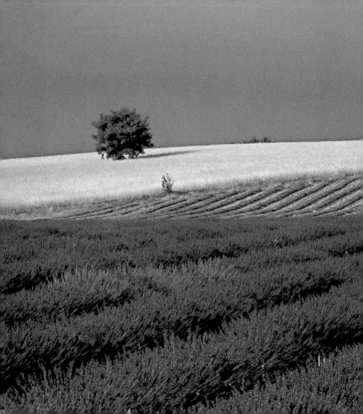

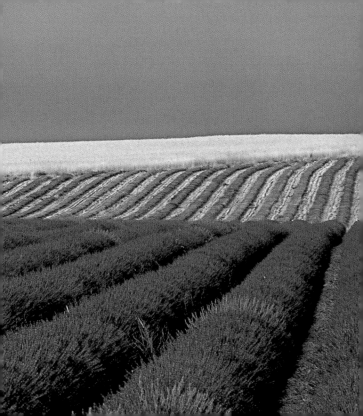

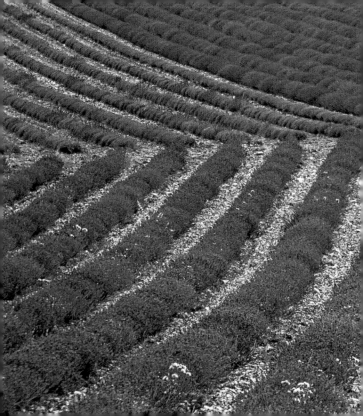

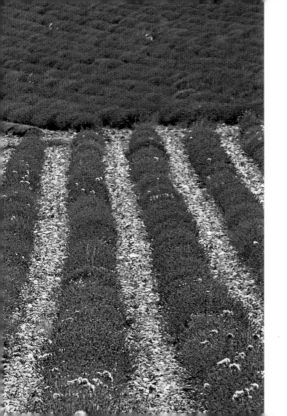

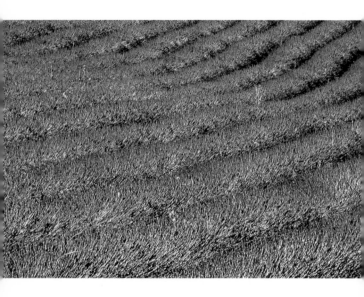

ABOVE AND OPPOSITE: *lavender* ❧❧ MONT VENTOUX REGION

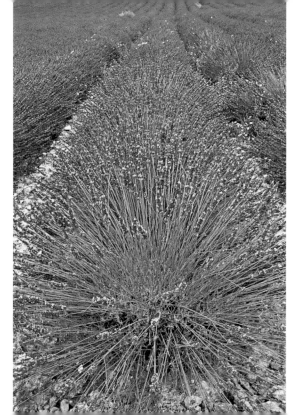

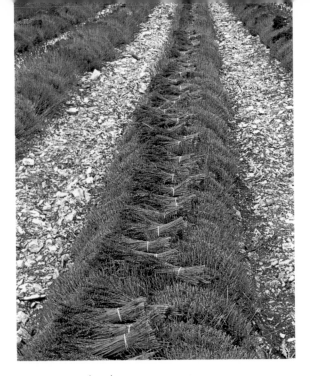

lavender ❦ MONT VENTOUX REGION

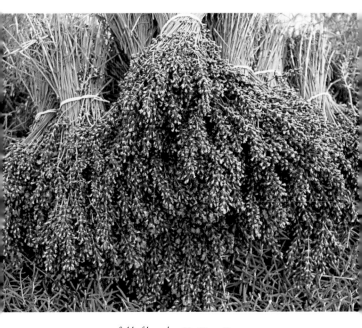

PAGES 74-75: *field of lavender* ❧ MONT VENTOUX REGION

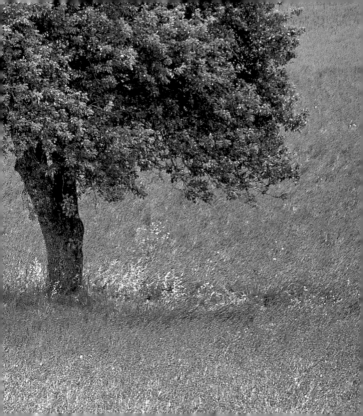

beetle on lavender ❧ MONT VENTOUX REGION

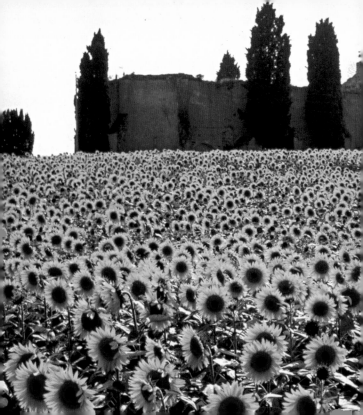

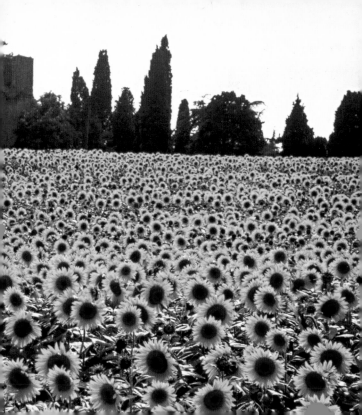

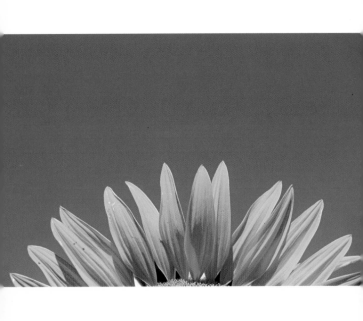

sunflower RHÔNE RIVER VALLEY

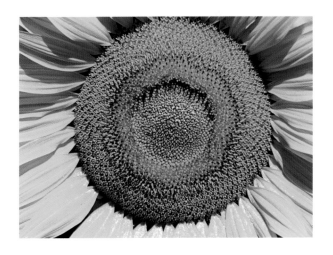

PAGES 82-83: *sunflower* ✍ MÉNERBES

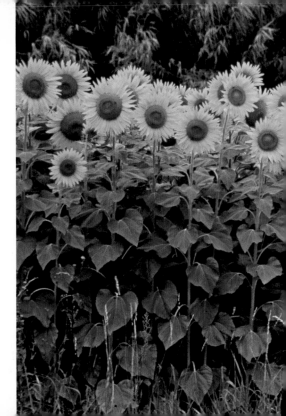

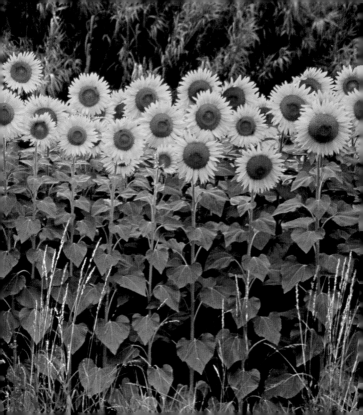

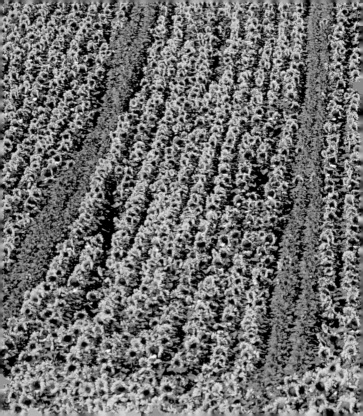

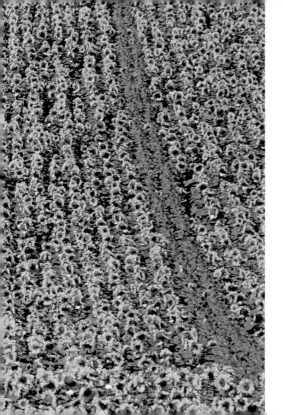

85

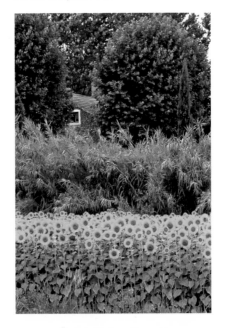

ABOVE: *sunflowers* ❧ SAINT-RÉMY-DE-PROVENCE

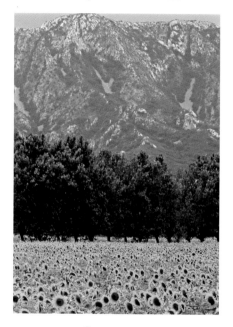

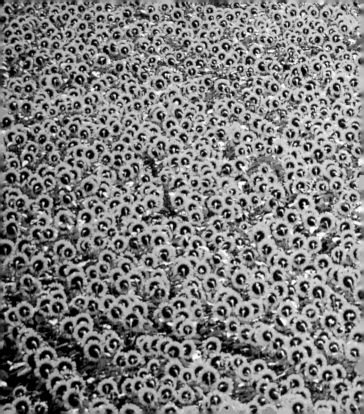

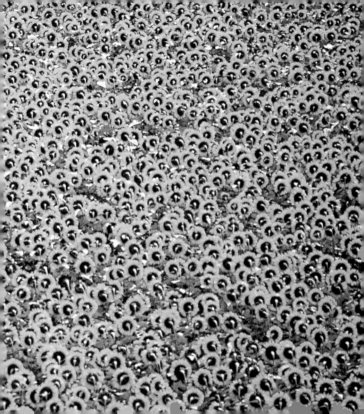

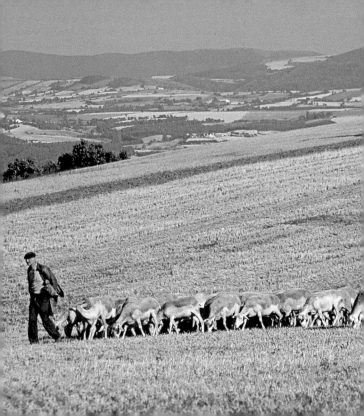

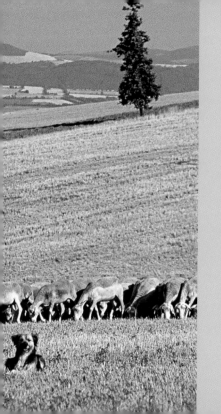

FARM LIFE

FARM LIFE

A shepherd arrives with his migrant flock, and a dog relaxing in the parched grass gazes imperiously at the photographer. Then the shepherd heads off, perhaps toward the stone house weathered by thirty-six thousand seasons at the foot of the Dentelles de Montmirail.

It's a bit surprising to find a cow and a goat here. They bring to mind imagery—the thick grass and animated skies of Normandy—that's at odds with the pure blue and the beating rays of the Midi. On the other hand, Provence could have been created expressly for cats. These animals know how to live, they love extreme heat. Could there be a happier earthly vision than that presented by chameleon-like tom-cats (gold-brown against pinkish brown) blending into the sunlight and the curved roof tiles? When one thinks that there are regions where clouds prevail and the tiles are flat . . .

PAGES 90-91: *shepherd* MONT VENTOUX

OPPOSITE: *cow in barn* NEAR SAULT

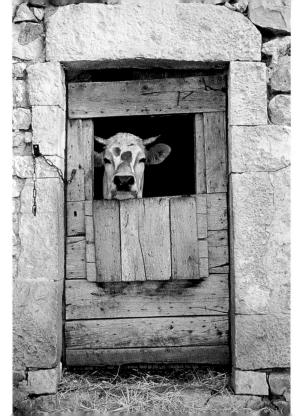

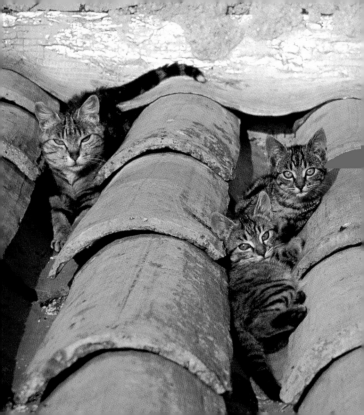

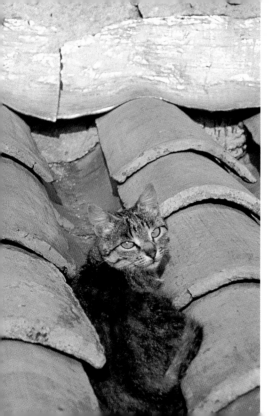

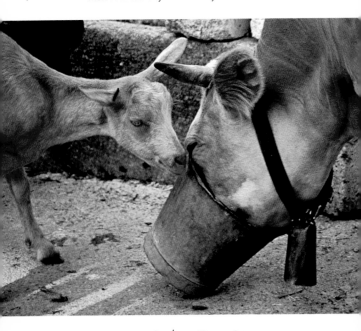

ABOVE: *goat and cow* ❧ NEAR SAULT

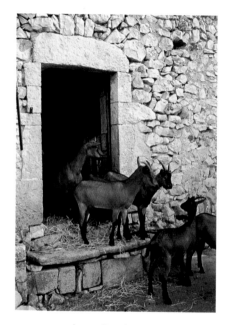

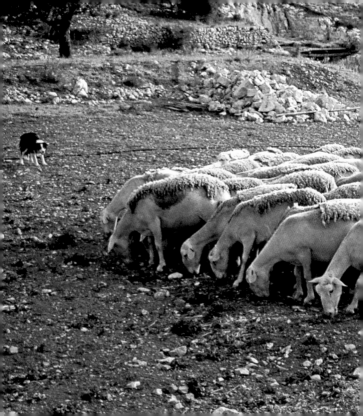

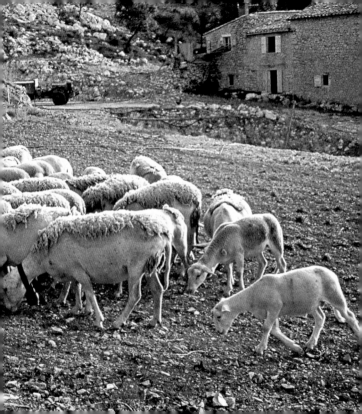

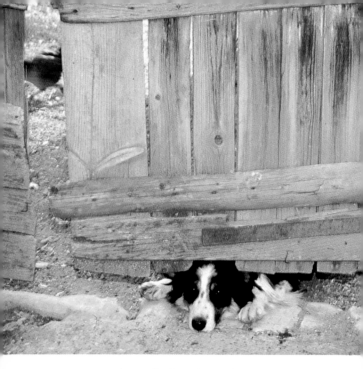

dog guarding barn 🙤 NEAR SAULT

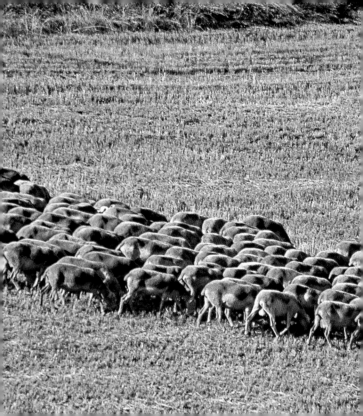

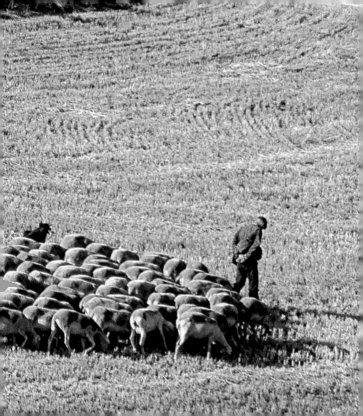

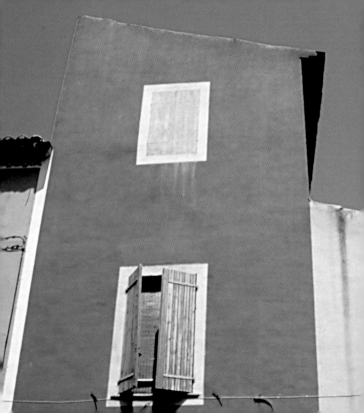

WINDOWS

WINDOWS

If windows are the soul of houses, then the soul of Provence is lavender blue, golden yellow, violet, and scarlet, sometimes decked out with flower boxes or adorned with cats, always opening onto mysteriously dark interiors. Sometimes a balcony traces a black filigree against the faded white of walls and shutters. In the asylum of Saint-Rémy, the windows do not have bars behind their pale blue swinging doors, but such was not the case for van Gogh's room: "Through the iron bars of the window I can take in an enclosed wheat field, a perspective suggestive of van Goyen, above which each morning I see the sun rise in all its glory." In Les Baux, a crumbling wall now allows azure rather than murderous invaders to pass through it. In Roussillon, a shutter that may never have been opened has unknowingly become, with the passing years, the bearer of a painter's dream: the perfection of a blue that has given way triumphantly to patches of red that are simultaneously brilliant and faded.

PAGES 104-105: *windows and walls* ☙ ROUSSILLON

OPPOSITE: *window* ☙ LOURMARIN

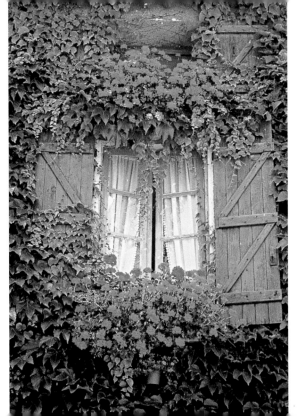

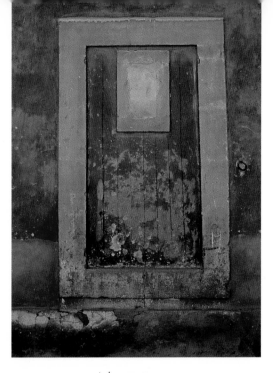

window ✺ ROUSSILLON

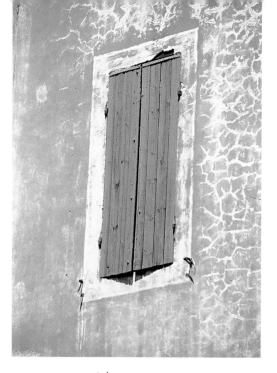

window � ornament Roussillon

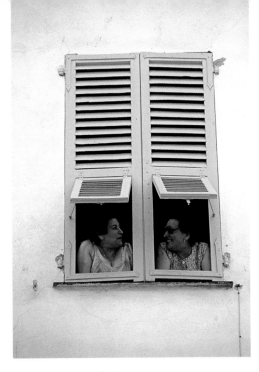

women chatting ❧ VILLEFRANCHE

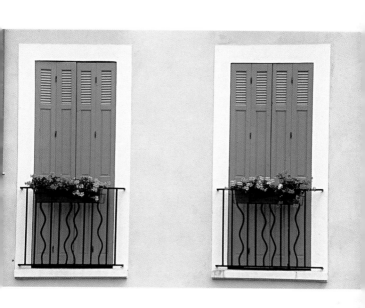

PAGES 112-113: *window* 🙰 MONIEUX

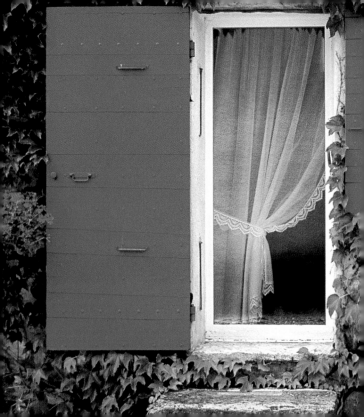

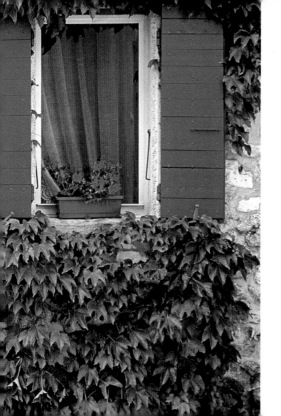

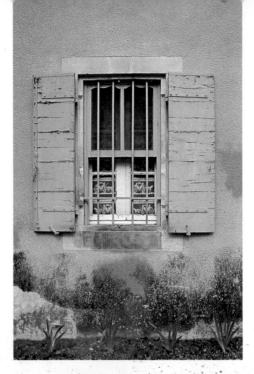

window SAINT-ETIENNE-DU-GRES

114

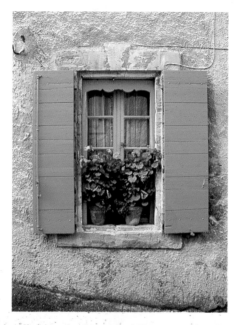

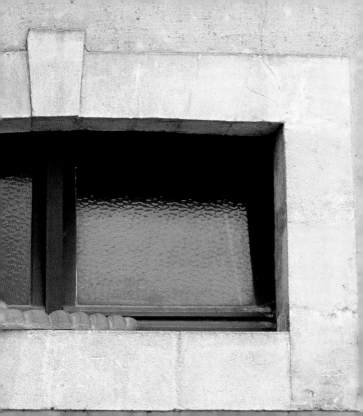

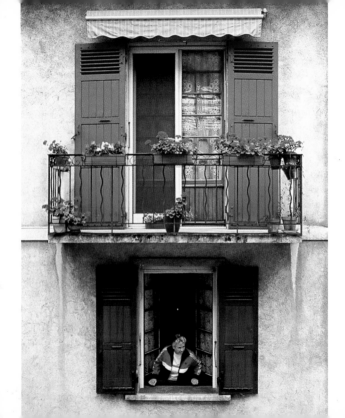

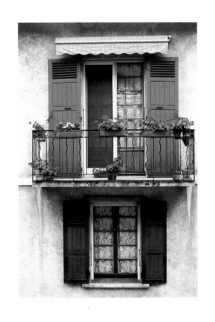

PAGES 120-121: *windows* ⟩⟨ TARASCON

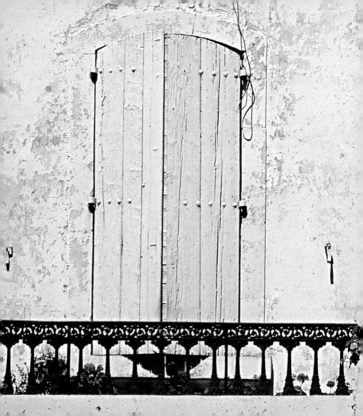

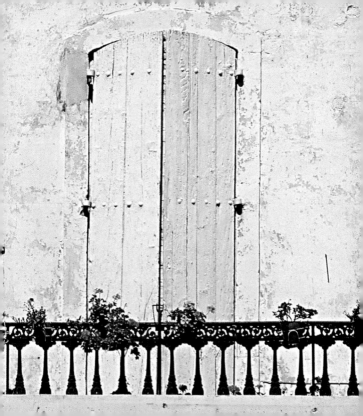

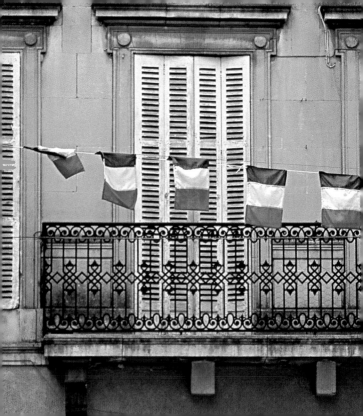

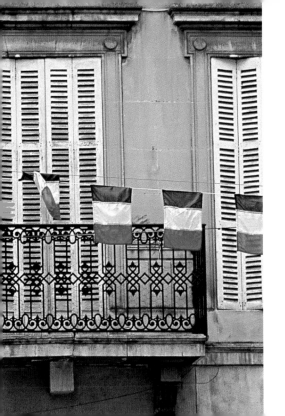

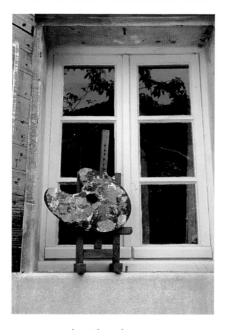

ABOVE: *easel outside window* ❧ EYGALIÈRES

mural next to windows ✍ ISLE-SUR-LA-SORGUE

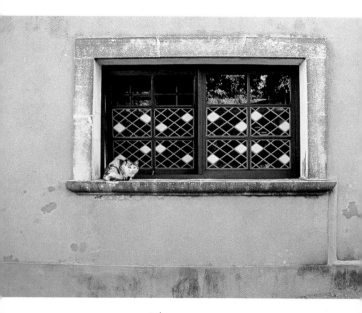

window ❧ BONNIEUX

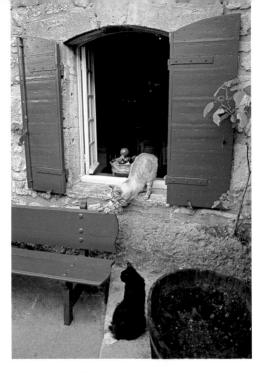

window ✌ LES BAUX-DE-PROVENCE

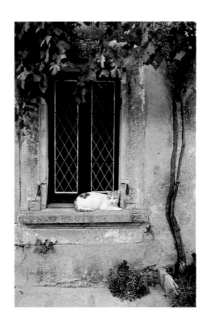

ABOVE: *window* LES BAUX-DE-PROVENCE

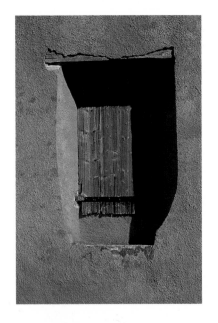

OPPOSITE: *The Palace of the Popes* ~ AVIGNON

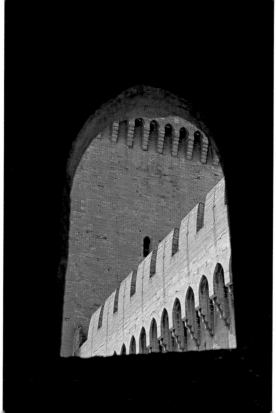

BELOW: *window in Saint-Paul-de-Mausole monastery/convalescent home, where van Gogh lived* ◈ SAINT-RÉMY-DE-PROVENCE

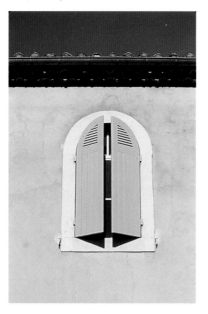

OPPOSITE: *window* ◈ LES BAUX-DE-PROVENCE

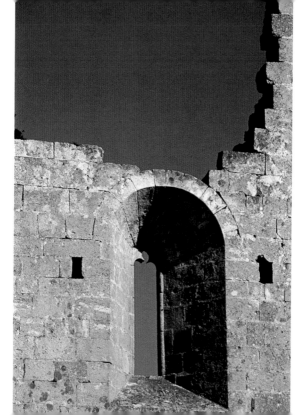

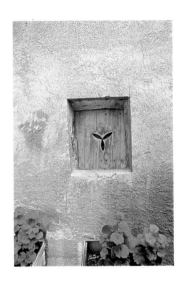

OPPOSITE: *window* ❧ LES BAUX-DE-PROVENCE

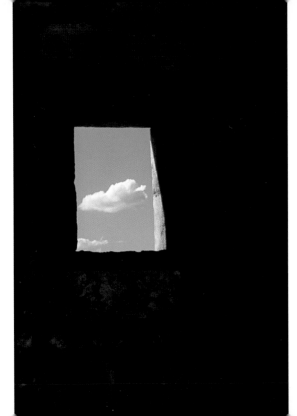

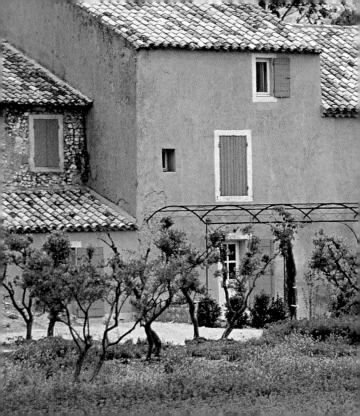

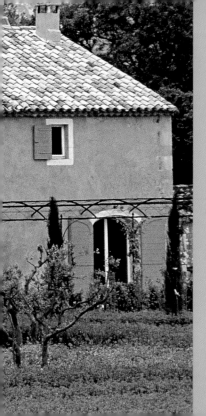

VILLAGES

VILLAGES

Sometimes everything blurs into monotony: the worn stone, the dust of the road rising in the heat, the pale ocher of the walls, the faded tiles—and an entire village beaten down by the sun, accepting this abuse with a resigned fatalism. And then in the market square everything comes alive and spruces itself up: cherries, raspberries, golden bread, peppers, and future ratatouilles (the perfume of their garlic and olive oil hovers in the air). The spices in baskets have as many colors as the bottled perfumes do scents. In front of the café on the square of Saint-Paul-de-Vence, Yves Montand has been captured playing pétanque—in a gesture like that of a sower, though slightly more exalted—and one longs for summer, one longs to take a seat on one of those wretched plastic chairs on the terrace, under the shadow of a tree, in the almost palpable torpor.

PAGES 136-137: *farmhouse near Eygalières* ⮑ LES ALPILLES

OPPOSITE: *village scene* ⮑ BONNIEUX

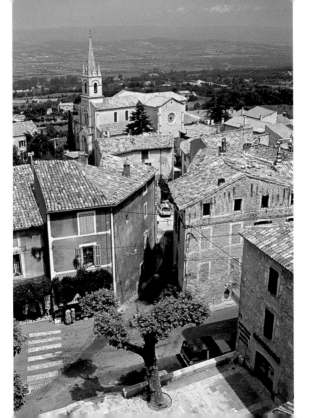

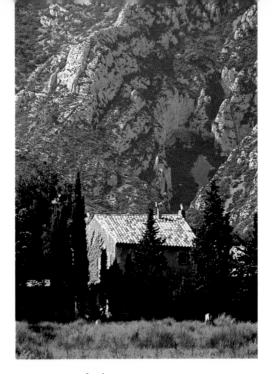

farmhouse ❧ LES ALPILLES

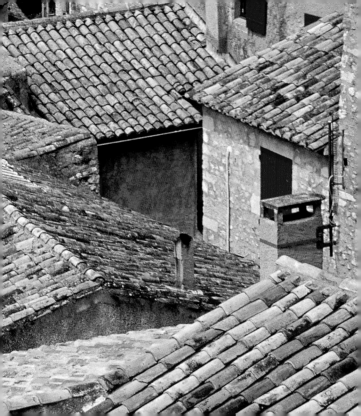

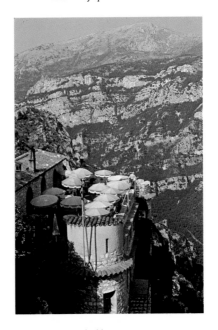

OPPOSITE: *buildings* ∾ GORDES

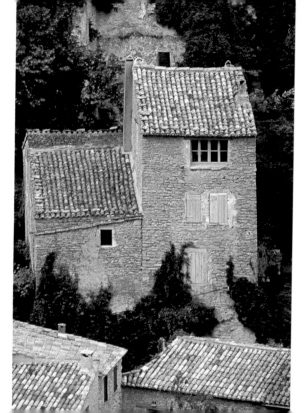

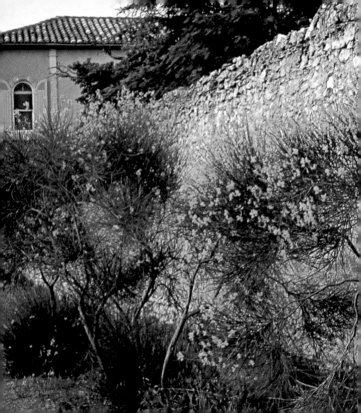

PAGES 146-147 *Saint-Paul-de-Mausole, monastery/convalescent home, where van Gogh lived* ❧ SAINT-RÉMY-DE-PROVENCE

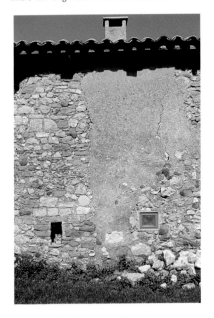

ABOVE: *farmhouse near village* ❧ SAULT

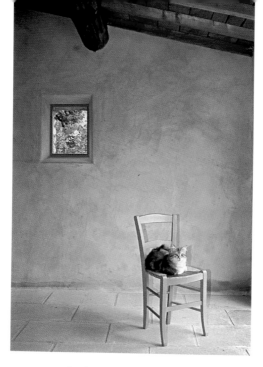

farmhouse near village ✵ SAULT

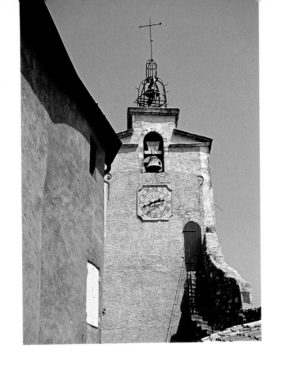

bell tower ⁂ ROUSSILLON

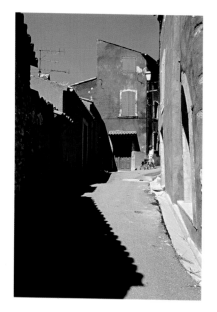

PAGES 152-153: *Yves Montand playing the game of pétanque*
✍ SAINT-PAUL-DE-VENCE

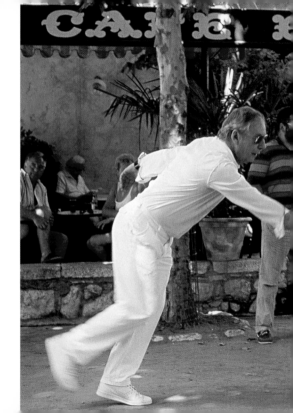

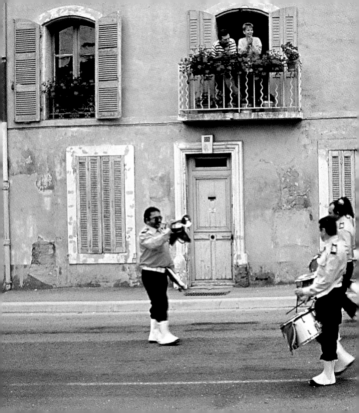

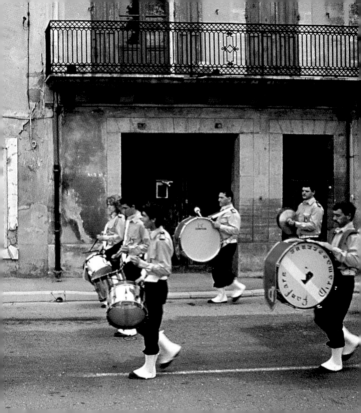

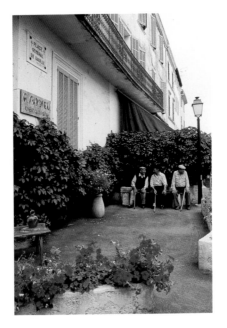

ABOVE: *village square* ❧ BIOT

156

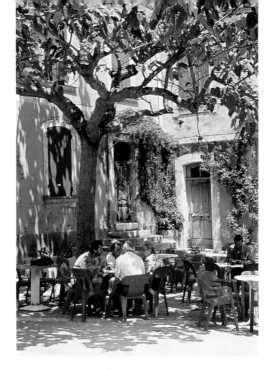

café ❧ Roussillon

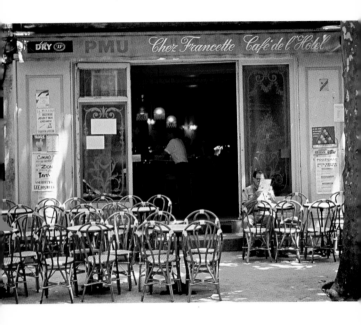

café 🙥 UZÈS

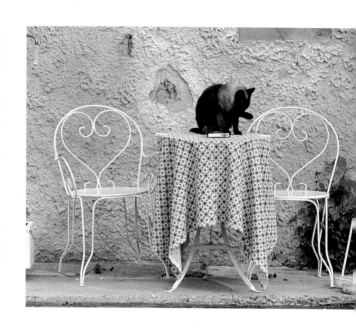

café 🐾 AUREL

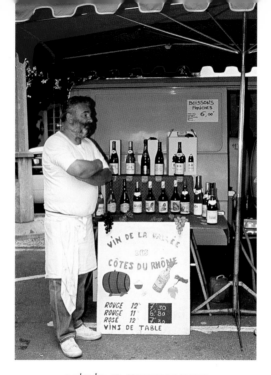

market day ❧ MAUSSANE-LES-ALPILLES

market day ☙ SAINT-RÉMY-DE-PROVENCE

ABOVE: *hotel* CHATEAURENARD

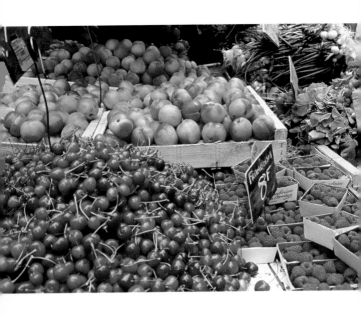

fruit Nîmes

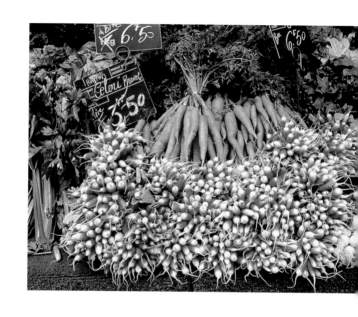

vegetables ✿ Tarascon

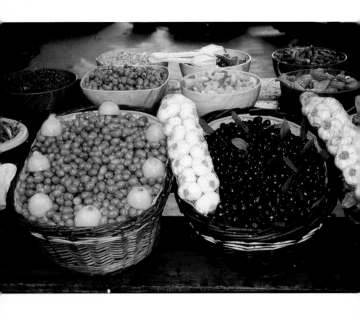

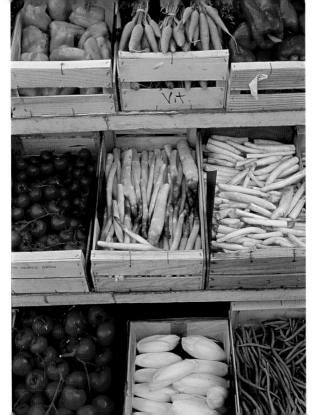

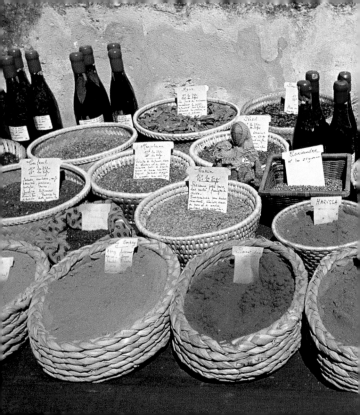

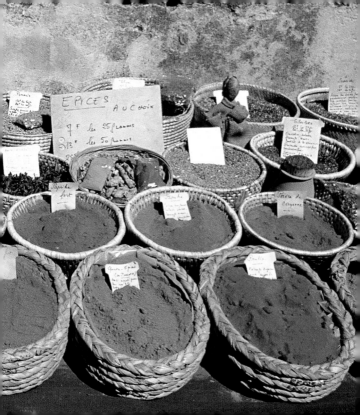

ABOVE: *restaurant* ❧ LES-BAUX-DE-PROVENCE

garden scene ❧ NEAR BEAUMES-DE-VENISE

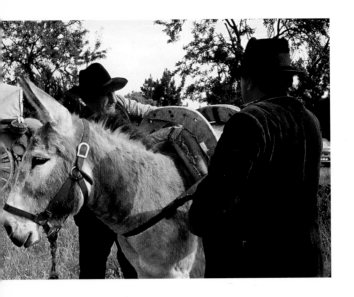

OPPOSITE: *girl in traditional dress* ✍ SAINT-RÉMY-DE-PROVENCE

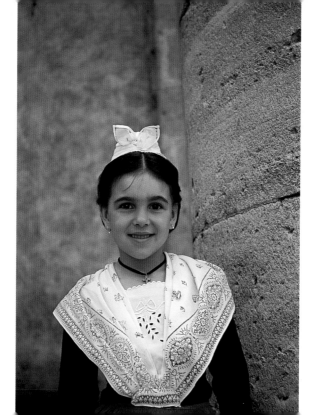

perfume shop ❧ GOURDON

perfume shop ✖ GOURDON

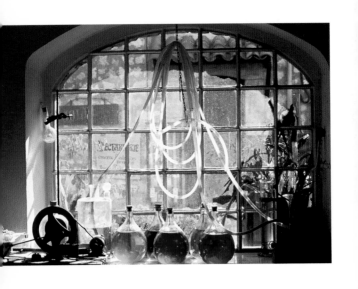

perfume shop 🙢 GOURDON

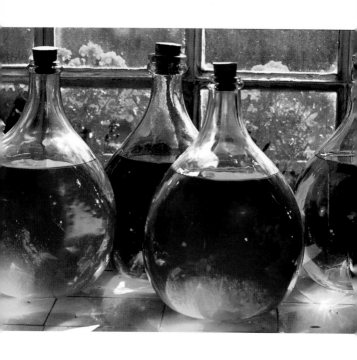

perfume shop ✿ GOURDON

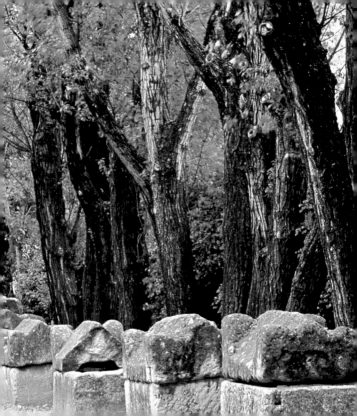

STONEWORK

STONEWORK

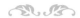

Did van Gogh know when he painted the Alyscamps and the Trinquetaille bridge that he was following a legend-laden itinerary? In effect, the ancient inhabitants along the Rhône are said to have set coffins bearing their dead adrift in the river, along with a small sealed box containing money to compensate the people of Trinquetaille—a neighborhood in Arles—for fishing them out and giving them eternal rest in the Alyscamps. Saint Trophime, whose own legend was sculpted on the portal of the church dedicated to him in Arles, blessed a sepulcher there for Christians.

Sculpted angels and saints, faces both tormented and ecstatic, the Sisteron cliffs, the Gordes road climbing toward the sky, the magnificent decapitated bodies of Saint-Rémy, the gray tombs of the Alyscamps thrusting upward among the dead—the stones of Provence, whether Roman or Romanesque, whether worked by man or by centuries of exposure to the elements, are haunted by memory.

PAGES 178-179: *Roman Necropolis at the Alyscamps* 🜲 ARLES

OPPOSITE: *stone stairway* 🜲 GORDES

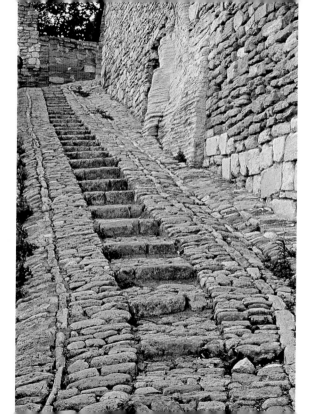

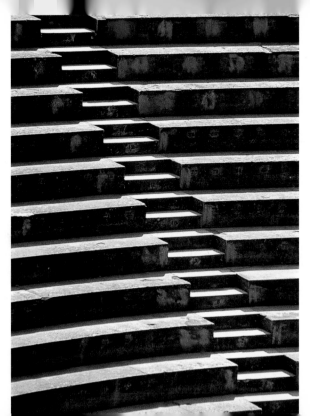

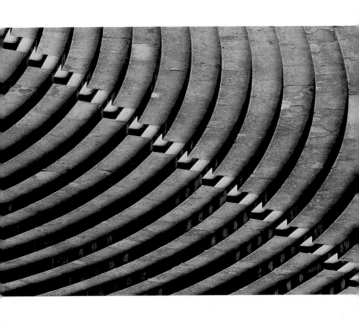

OPPOSITE AND ABOVE: *steps at a Roman theater* ❧ ❧ ORANGE

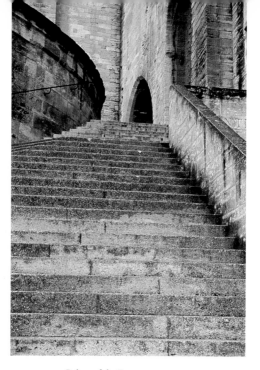

Palace of the Popes ❧ Avignon

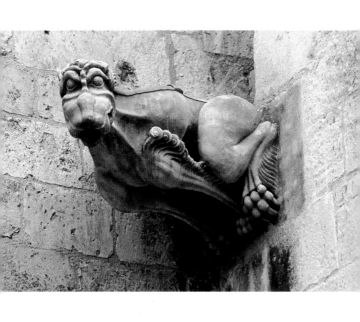

Roman relief and gargoyle ✍ THE ALYSCAMPS, ARLES

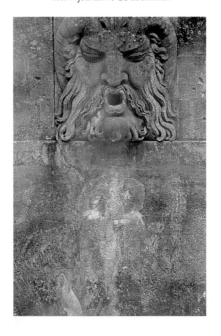

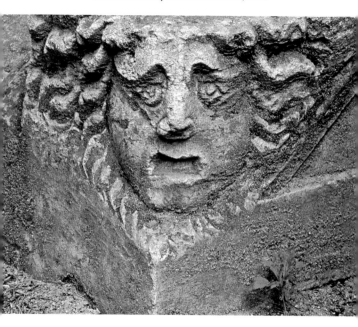

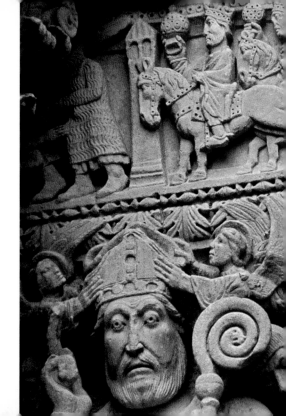

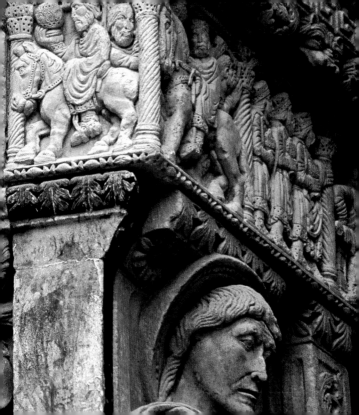

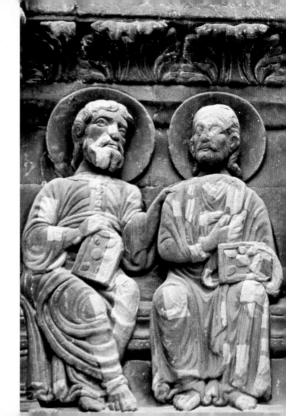

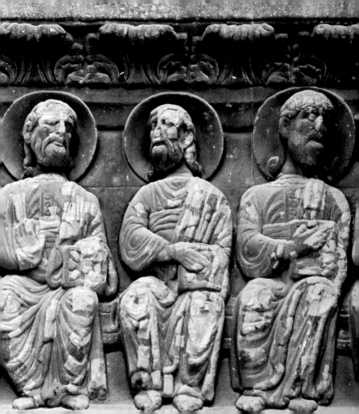

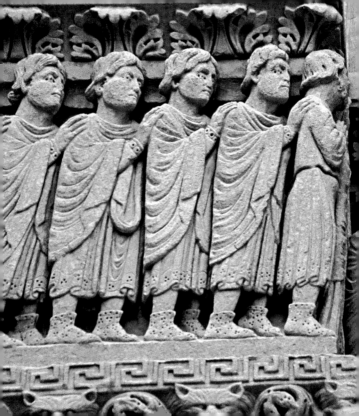

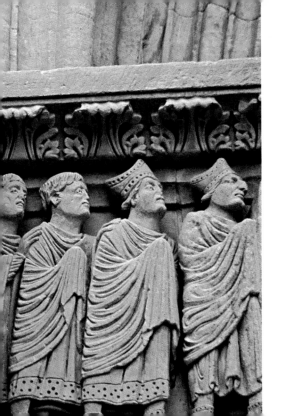

ABOVE: *detail from a Roman theater* ⟋ ARLES

194

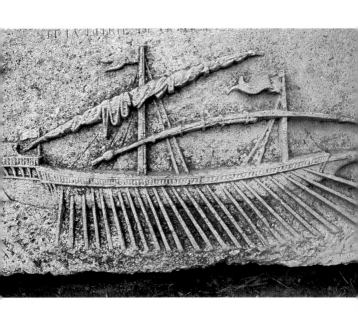

detail of Roman ship ✣ A<small>IGUES</small>-M<small>ORTES</small>

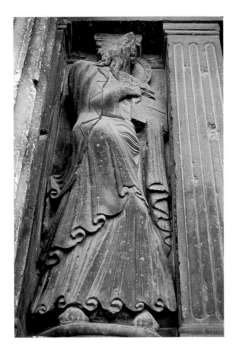

sculpted figure on church façade ❧ Saint-Gilles

Roman column ∫∂ THE ALYSCAMPS, ARLES

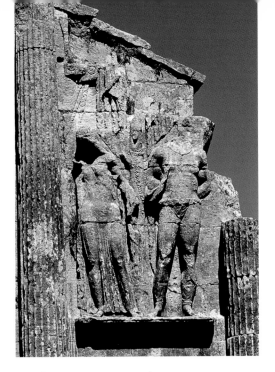

detail of Roman commemorative arch ❧ Saint-Rémy-de-Provence

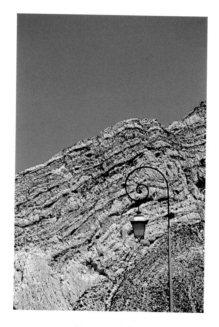

PAGES 200-201: *Roman amphitheater* ❧ ARLES

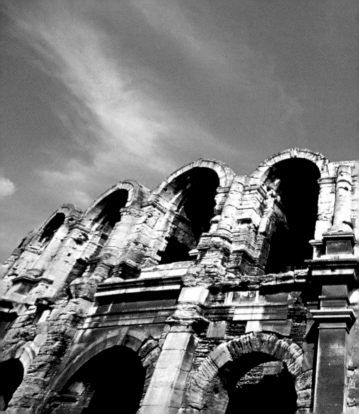

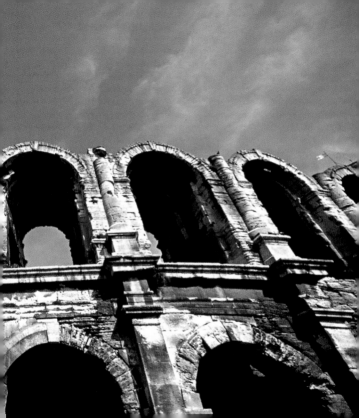

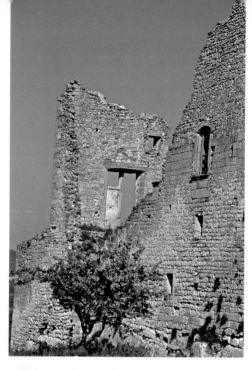

ruins of the Marquis de Sade's Château de Lacoste ⤬ LUBÉRON REGION

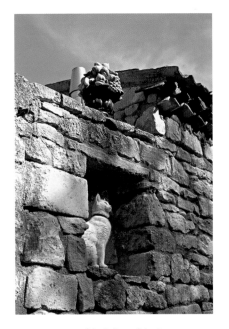

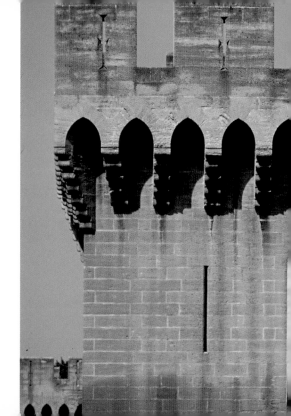

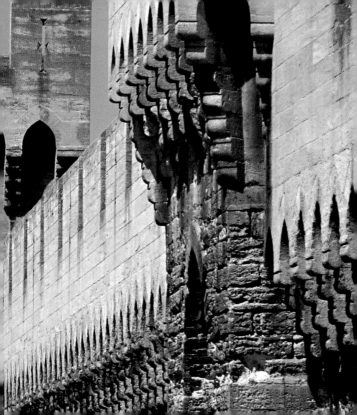

BELOW: *Fenestrelle Tower* ↤ UZÈS

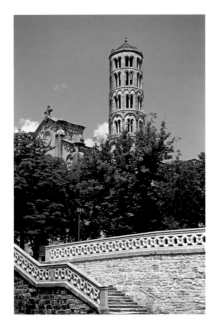

OPPOSITE: *Saint Sauveur cathedral* ↤ AIX-EN-PROVENCE

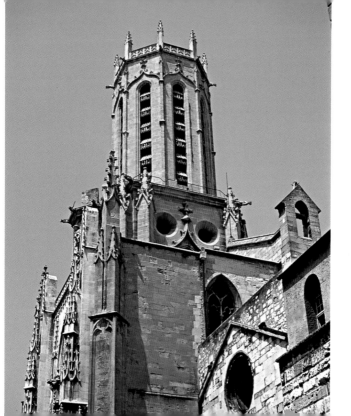

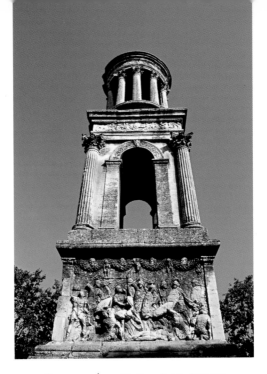

Roman mausoleum ❧ Saint-Rémy-de-Provence

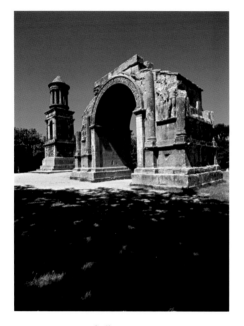

PAGES 210-211: *view of village* 🙠 SAINT-PAUL-DE-VENCE

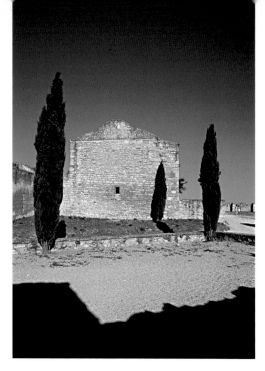

cypress trees flank a stone chapel ❧ LES BAUX-DE-PROVENCE

PAGES 214-215: *cypress trees behind a stone wall* ❧ GORDES

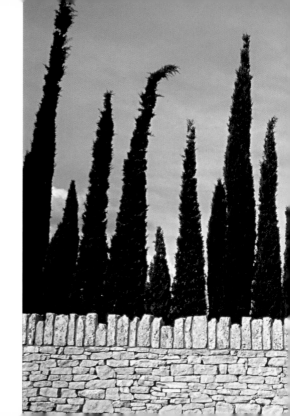

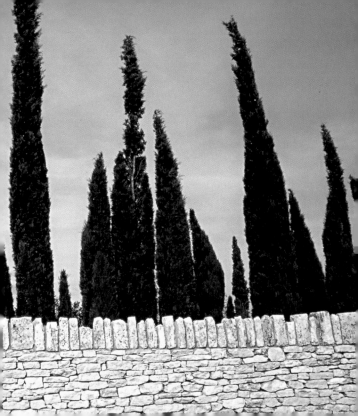

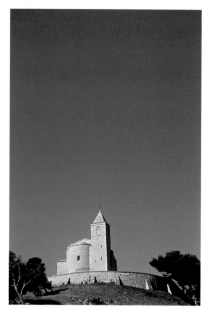

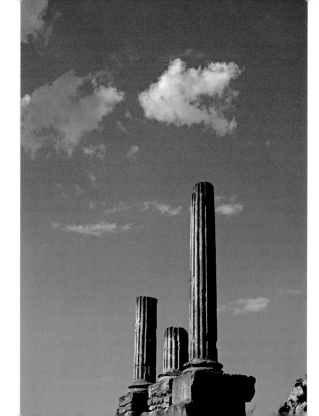

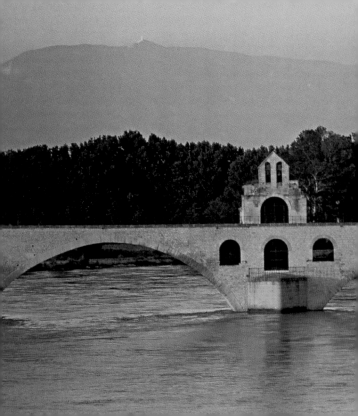

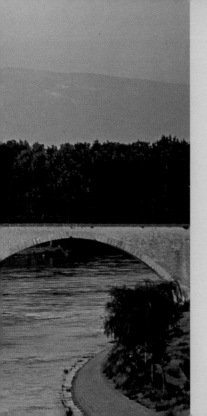

CITIES

CITIES

Miraculously constructed by a child, destroyed by the furies of the Rhône and winter weather, the Avignon bridge is restored to us intact, thereby reviving the dream of an indestructible bridge of nineteen arches.

At Avignon, in a Provence decimated by plague—it carried off Petrarch's Laura as well as the wife and two children of Nostradamus—and constantly crisscrossed by warring armies, the popes built themselves a palace, "the strongest, most beautiful house in the world," according to Froissart.

Memories of Cézanne hover over the fountains of Aix, while ghosts of van Gogh's companions in the Saint-Rémy asylum seem to inhabit its peaceful light—"honorable lunatics who always wear a hat, glasses, a cane, and a traveling outfit, rather as though they were at a seaside resort."

PAGES 218-219: *bridge at dusk* ⟡ AVIGNON

OPPOSITE: *La Major Cathedral* ⟡ MARSEILLES

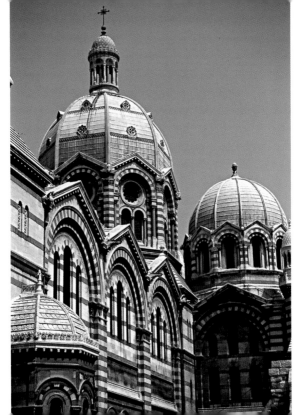

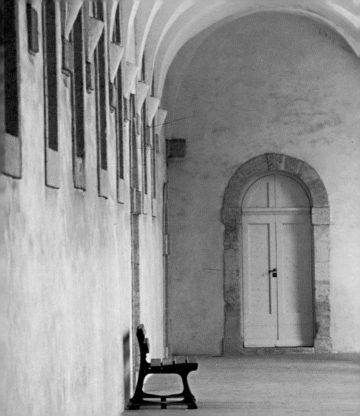

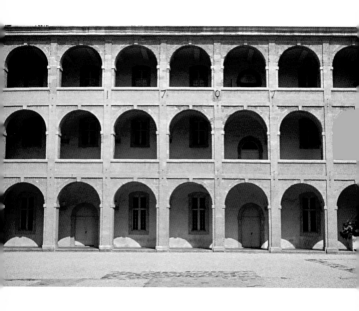

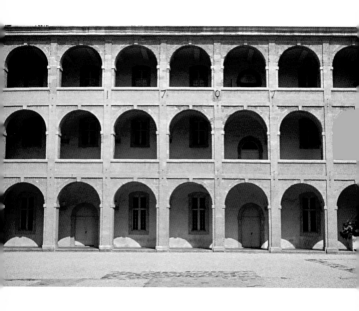

ABOVE: *Old Charity* 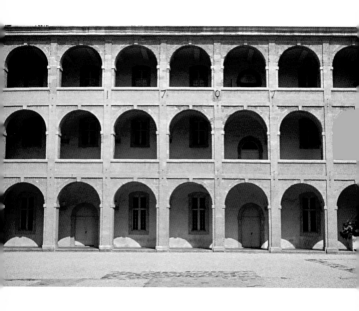 MARSEILLES

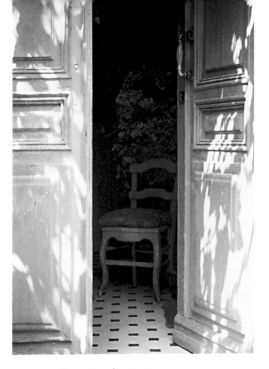

Cézanne's studio ❧ AIX-EN-PROVENCE

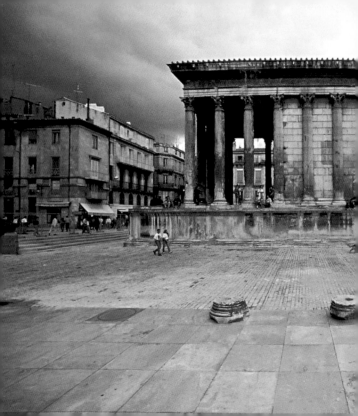

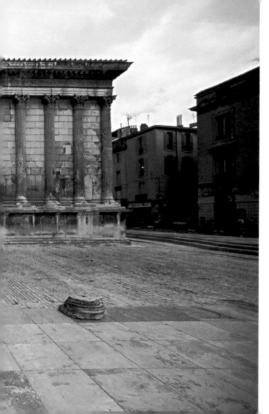

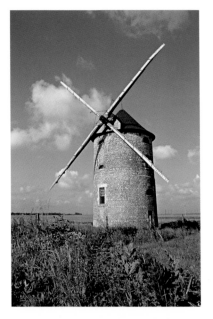

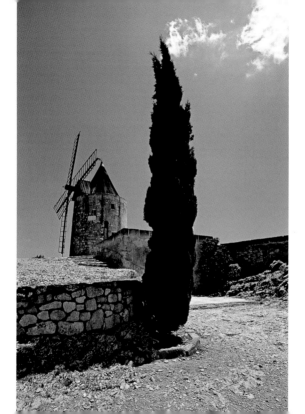

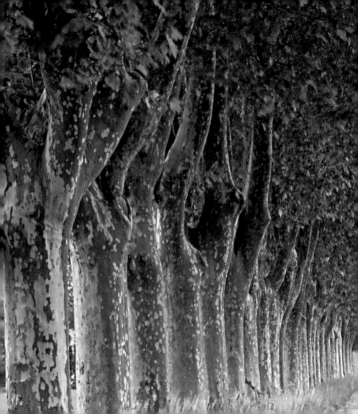

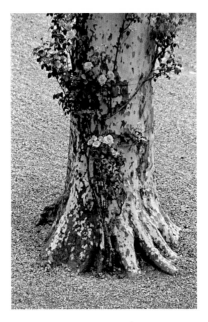

ABOVE AND OPPOSITE: *roses on tree trunk* 🙜 AIX-EN-PROVENCE

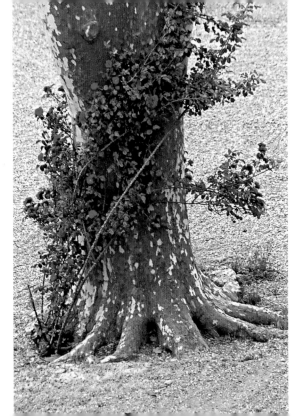

ABOVE: *Van Gogh Square* ❧ ARLES

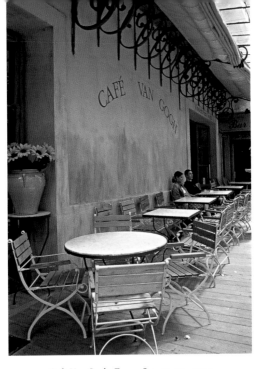

Café Van Gogh, Forum Square ❧ ARLES

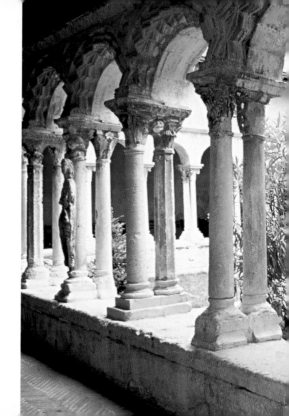

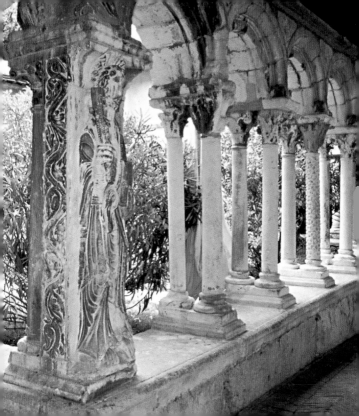

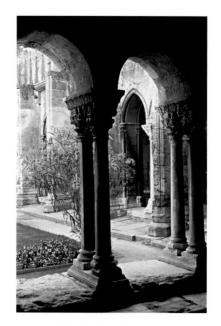

ABOVE: *Saint-Trophime Cloister* ✖ ARLES

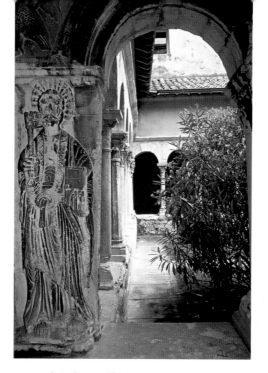

Saint Sauveur Cloister ❧ AIX-EN-PROVENCE

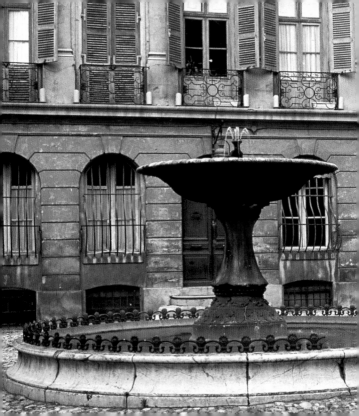

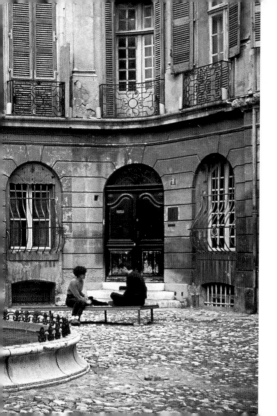

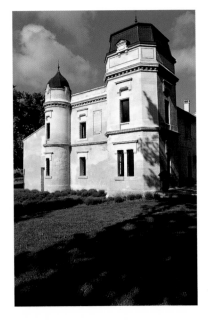

OPPOSITE AND ABOVE: *Domaine Sainte-Anne* 🙥🙢 ARLES

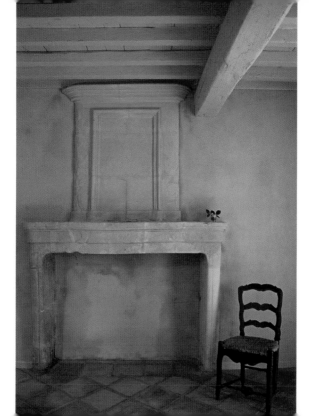

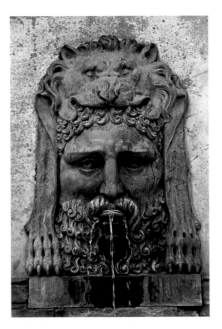

ABOVE AND OPPOSITE *fountain* ⤞ ARLES

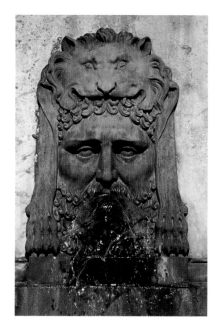

PAGES 248-249, 250-251: *view of city* ❧ AVIGNON

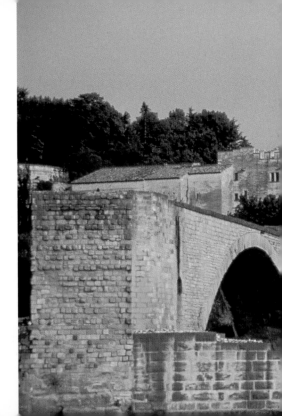

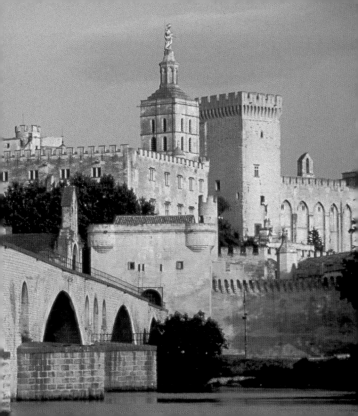

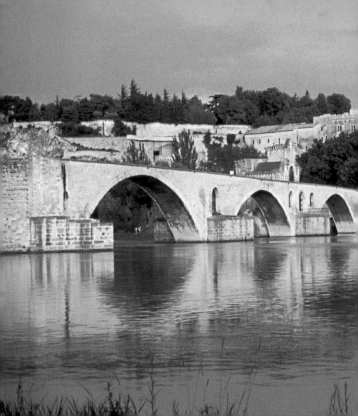

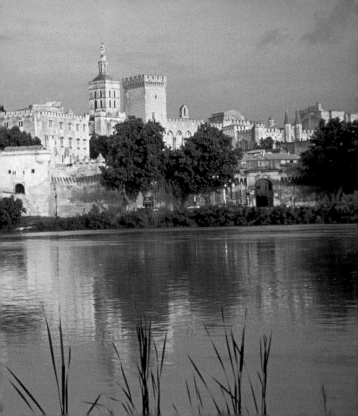

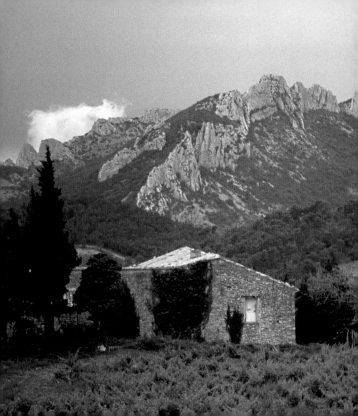

LANDSCAPES

&

SEASCAPES

LANDSCAPES & SEASCAPES

All the many Provences are here. Cézanne's Mont Sainte-Victoire, which Giono saw as having "fantastic sails of white rock, like a phantom ship in full daylight."

White sails, real ones this time, tiny against the blue horizon, and a village perched among flowers—such were the two poles orienting Colette's happiness: "I love Provençal towns wedded to the dry summits of their hills. . . . But in summer I soon weary of seeing nothing but land; I begin to thirst for the sea, for its inflexible horizontal suture, blue against blue."

And then there's that exceptionally clear light that bathes both earth and sky. Almost every spring, Bonnard painted the same almond tree flowering in his garden. Working on the last canvas in this series in the year of his death, he still sought to uncover the secret of the vibrating colors in this light: "That green, on the patch of ground in the lower left, doesn't work. It needs some yellow . . ."

PAGES 252-253: *vineyard* ∽ LES DENTELLES DE MONTMIRAIL

OPPOSITE: *ocher cliffs* ∽ ROUSSILLON

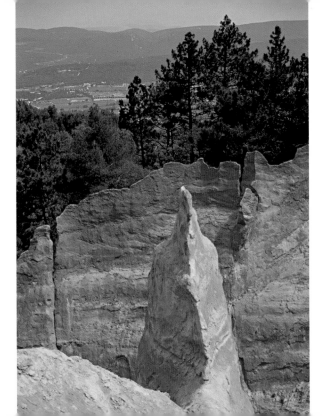

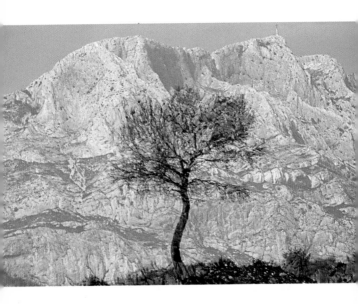

ABOVE: *Cross of Provence* 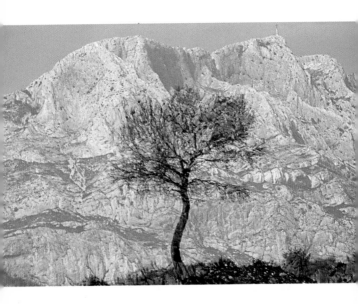 Sainte-Victoire Mountains

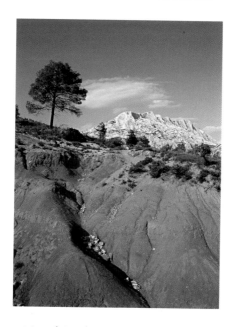

PAGES 260-261: *vineyards in early morning* ॐ Les Dentelles de Montmirail

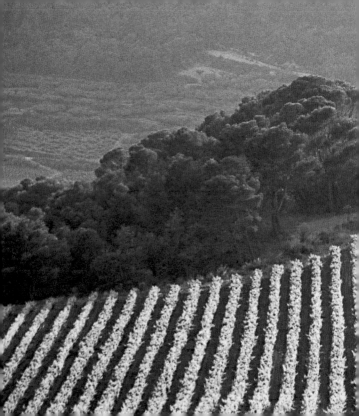

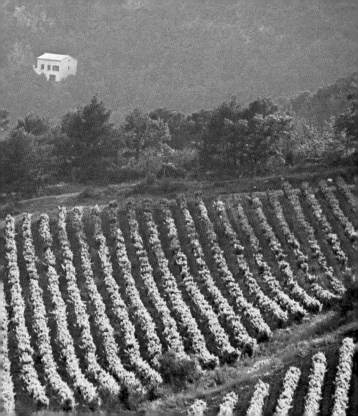

eroded cliffs ❧ LES BAUX-DE-PROVENCE

PAGES 264-265: *church on cliff* CASTELLANE

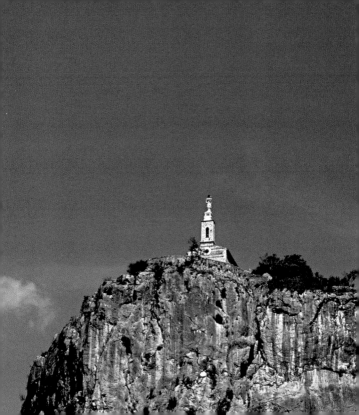

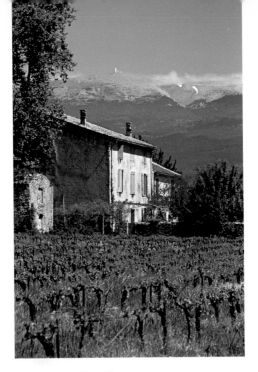

view of Mont Ventoux ❦ CARPENTRAS

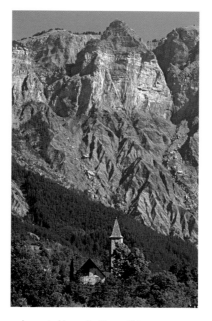

PAGES 268-269: *broom in bloom, La Roque Alric* ✍ BEAUMES-DE-VENISE

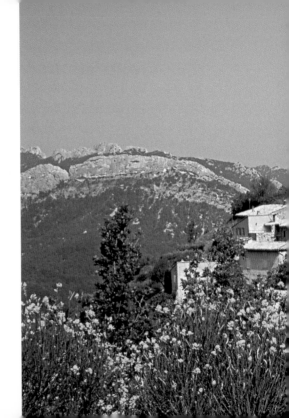

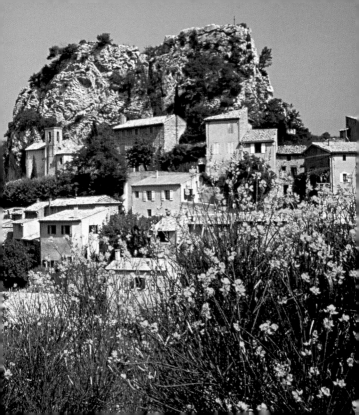

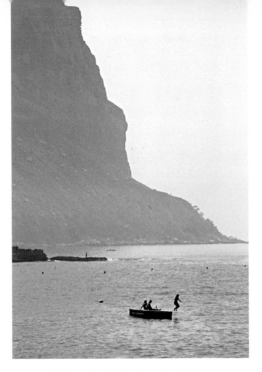

cliffs along the Mediterranean Sea CASSIS

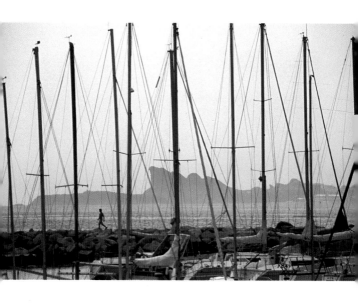

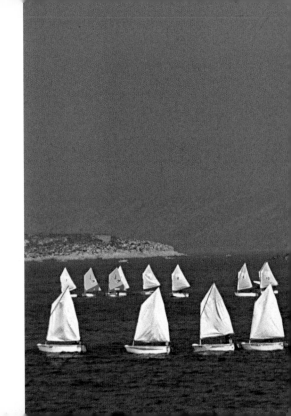

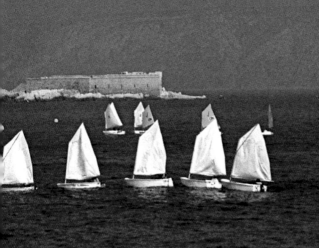

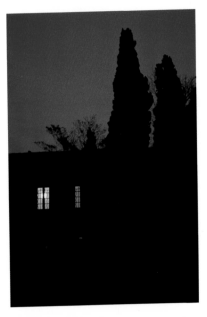

ABOVE: *Saint-Paul-de-Mausole* ∾ SAINT-RÉMY-DE-PROVENCE

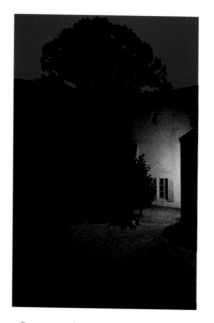

PAGES 278-279: *Roman mausoleum at sunset* ❧ SAINT-RÉMY-DE-PROVENCE

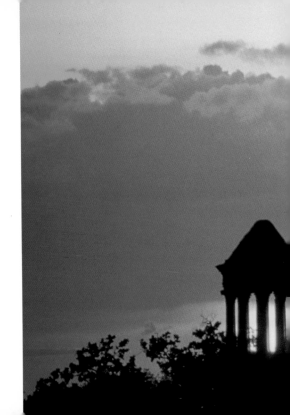

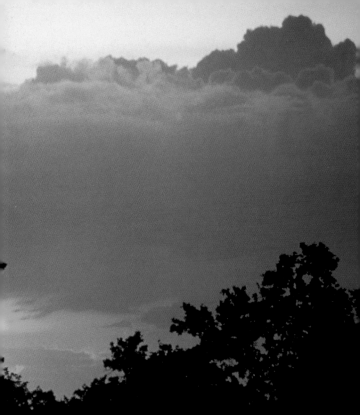

ACKNOWLEDGMENTS

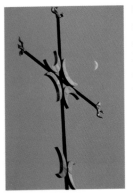

Our great thank you to Susan Costello for believing in this book and pulling it all together. We are also grateful to Patricia Fabricant for her talent and enormous patience and to Marike Gauthier for her good advice and generous contribution of time to the project. And we are indebted to Robert Abrams for allowing us to create our book.

We would like to say "thank you" to all our friends for their encouragement. We would also like to express our appreciation to our friends at the Image Bank. And we send a special "thank you" to our French friends for their help: Danielle and Michel Droy; Anne-Sarah Fayet; Huguette and Alfred Giuliato; Andrée and Pierre Liardet; Jacques Lumia and his band—sapeurs-pompiers de Miramas; M. and Mme. Menant; Myriam and Patrick Thiant; and the many friendly "Provençaux".

Matisse's Chapel of the Rosary VENCE

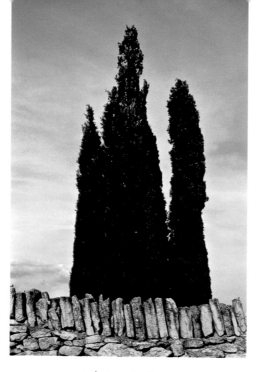

poplar trees ✍ GORDES

⤳ INDEX ⤳

✧ ABOUT THE PHOTOGRAPHERS ✧

Sonja Bullaty and Angelo Lomeo are a prize-winning husband-and-wife team who live in New York City. Among their previous books are Abbeville's *Tuscany*, *Venice and the Veneto*, and *America, America*. Their photographs are widely collected and exhibited by galleries and museums, including the Metropolitan Museum of Art.

✧ ABOUT THE AUTHOR ✧

Marie-Ange Guillaume, a French journalist living in Paris, has written several biographies and works of non-fiction.

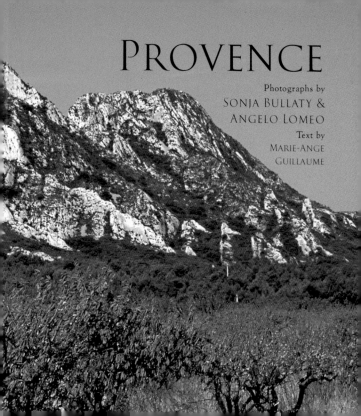

PROVENCE

Photographs by
SONJA BULLATY &
ANGELO LOMEO

Text by
MARIE-ANGE
GUILLAUME

CONTENTS

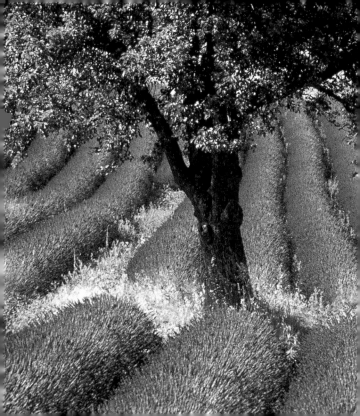